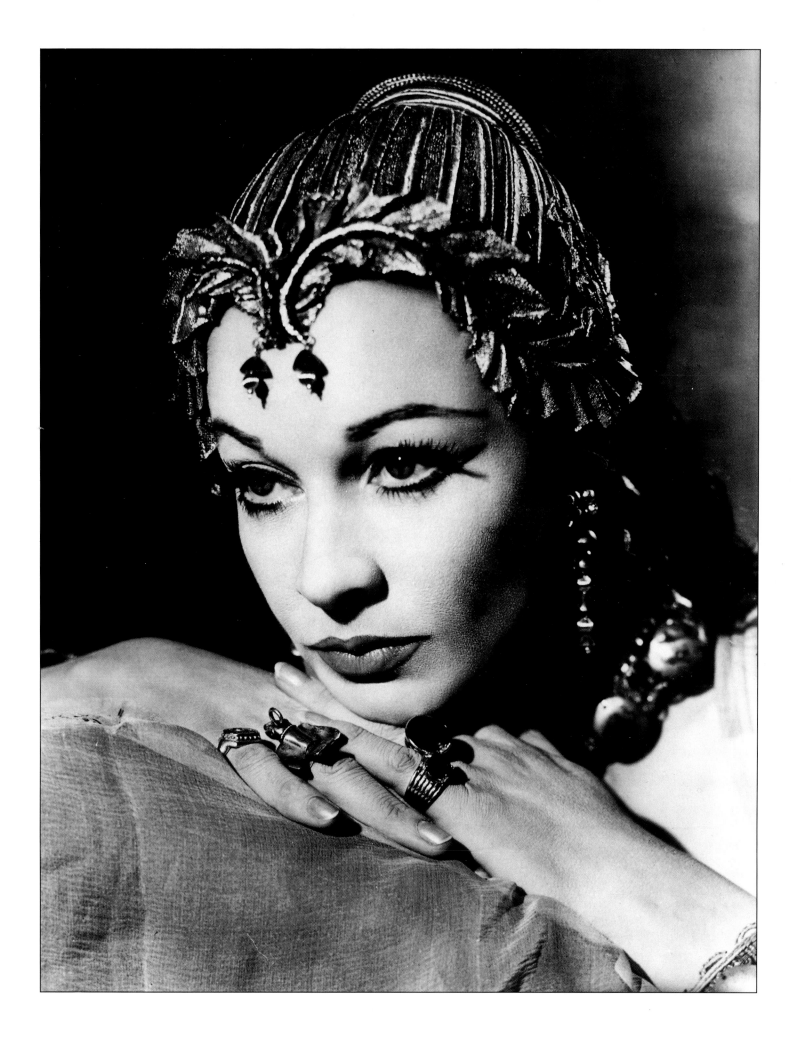

A · LOVE
AFFAIR
IN · CAMERA

Edited · by

· ADRIAN ·

WOODHOUSE

PHAIDON · OXFORD

VIVIEN

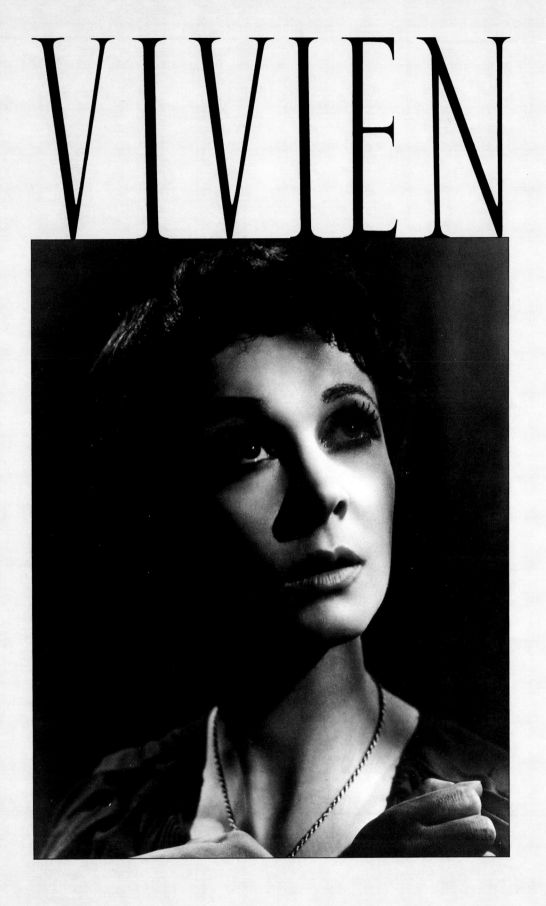

ANGUS McBEAN

As Viola in *Twelfth Night*, cast up on the shores of Illyria. Stratford, April 1955.

(*Half-title page*) Vivien in Shaw's *Caesar and Cleopatra*, which opened at St. James's Theatre, London, in May 1951.

(*title page*) Appearing as Antigone in 1948. This was amongst the first pictures of the Oliviers taken after the war.

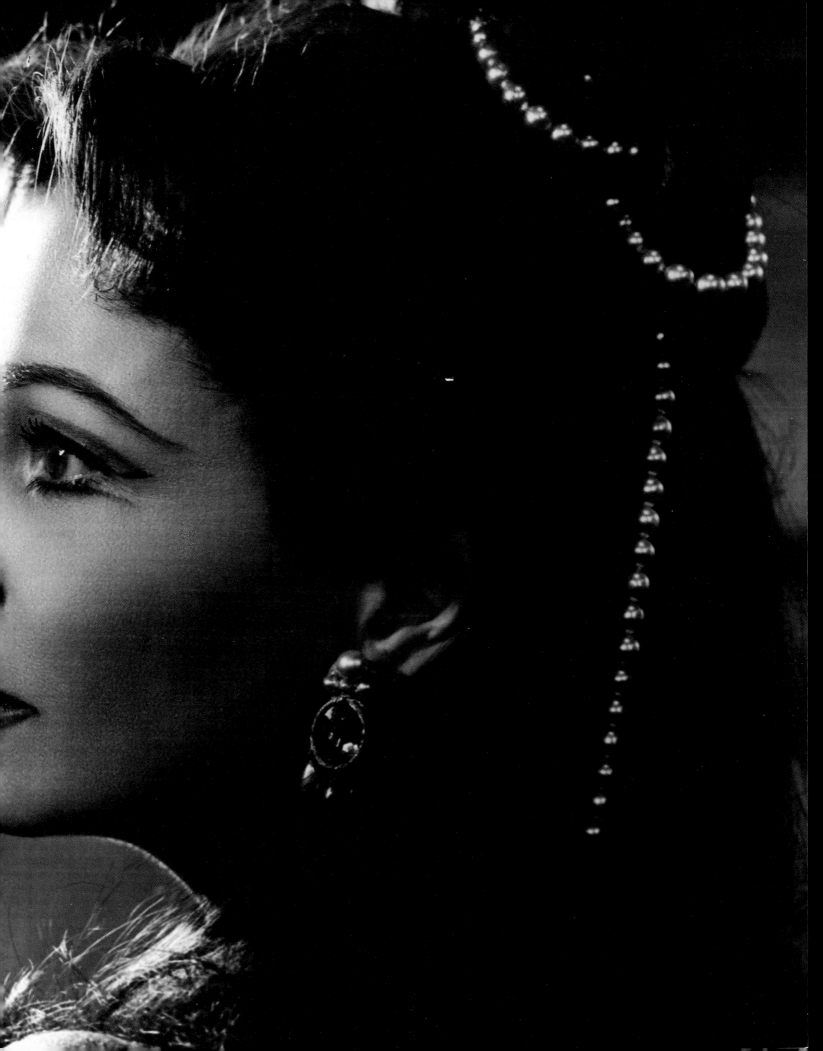

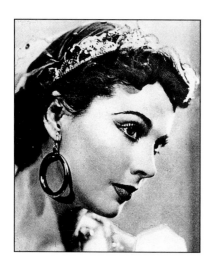

(*this page, top left*) My very first portrait of Vivien, appearing in *The Happy Hypocrite* with Ivor Novello in 1936; (*below left*) As 'Cesario' in *Twelfth Night*, 1955; (*below right*) Studio portrait 1955; (*opposite page, top*) A press shot taken during the run of *South Sea Bubble,* 1956; (*bottom*) 'Ordinary' shot from the last sitting, 1967.

Phaidon Press Limited,
Musterlin House, Jordan Hill Road,
Oxford OX2 8DP

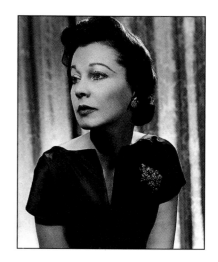

First published 1989
© 1989 Phaidon Press Limited

Text © 1989 Angus McBean
Illustrations © Angus McBean

A CIP catalogue record for this book is available from the British Library.

ISBN 0 7148 2580 8

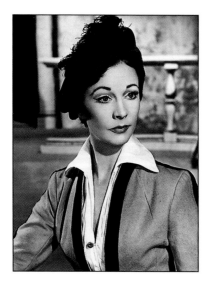

Typeset in Perpetua by Tradespools Limited, Frome, Somerset

Printed in Great Britain by Butler and Tanner Limited, Frome, Somerset

CONTENTS

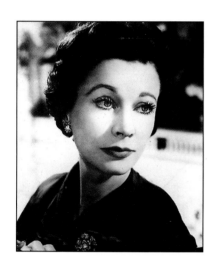

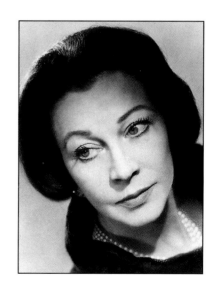

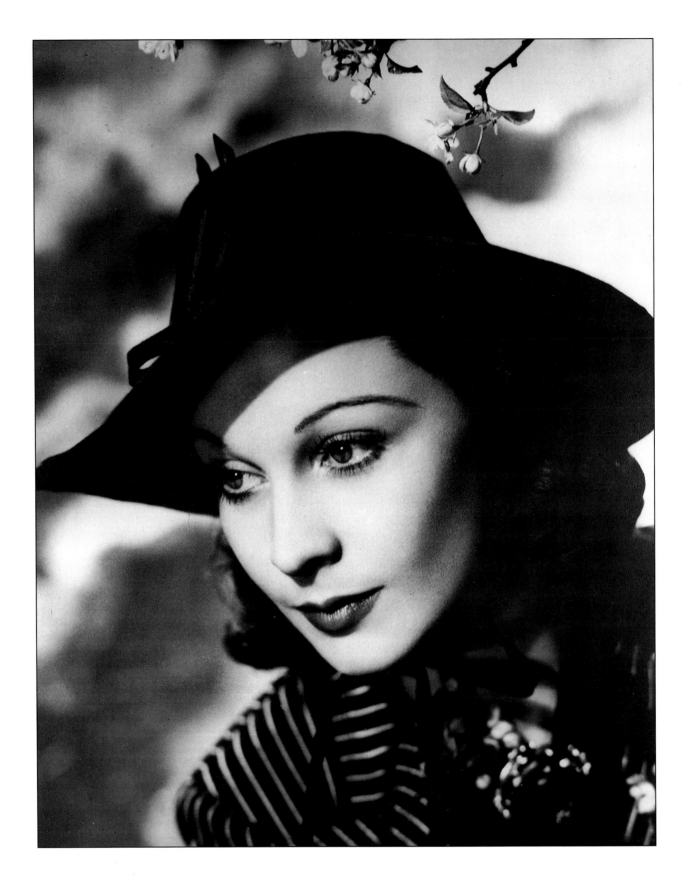

My favourite picture of Vivien, taken in
1937 and used as part of her campaign to
play Scarlett in *Gone with the Wind*. This was
used on a postage stamp in 1985 to celebrate
British Film Year.

PREFACE

Only one photographic portrait hangs on the wall in my house. It is my favourite picture of all the hundreds of thousands I have taken throughout what has turned out to be a very long career.

The portrait is of Vivien Leigh in a dashing black hat and was taken on her first visit to my studio as a private sitter. I didn't know at that sitting, but it was the opening shot in her campaign to secure for herself the part of Scarlett O'Hara in the film, *Gone with the Wind*. The photographs were to be sent to the producer David Selznick in Hollywood.

I also didn't know that I was to take hundreds more pictures of her for the rest of her tragically all-too-short life. However, I'm privileged to say that I did so for the next thirty years. She was the most beautiful woman I ever photographed and remained so, I believe, right up until the haunting last sitting just before her death in 1967. Of course I am biased – I was more than a little in love with her.

But Vivien was also a great actress, and exceptional beauty is a doubtful gift for an actress. She spent much of her life trying to live down the extraordinary looks that she possessed and prove herself on the stage. However, there is no question that she was the greatest international female film star that England has ever produced. It was very gratifying when, for British Film Year in 1985, designer Keith Bassford chose Vivien for his series of British film stamps, and made a 31p stamp out of the black hat photograph, my favourite (*see jacket flap*).

My friend Adrian Woodhouse had the idea of collecting together all the pictures that I took of Vivien. The thirty-year relationship between a photographer and a great actress and beauty was, he suggested, unique. Certainly I think I was extremely lucky that the very first pictures which launched me on a new career as a photographer happened to include Vivien Leigh.

Once the long job of assembling all the photographs for this selection had been finished I began to see the pictures afresh. In my opinion, there *is* a quality about them that is different to those taken of Vivien by other photographers. I suppose in part it was because of my special feelings for her but, in return, I believe she had affection for me and, above all, she trusted me. Vivien disliked, almost feared, the still camera – this was surprising, since she was so confident in moving pictures. But she knew me and she also knew that I would never use or publish a picture that she had not seen and approved.

Having collected the photographs together, it was clear that I should write something by way of an explanation. So much has been written about Vivien already and so much of it dwells on the so-called 'dark' side of her life that I felt it was time there was some light. I never experienced the 'dark' side of her – except for perhaps a glimpse on one or two occasions – and I see no reason why we should continue to concentrate on what, in her case, was a condition caused by actual physical illness. And, after all, what I am recording is chiefly the relationship between a great actress and a working photographer.

Before I begin I must thank a number of people who have so kindly lent prints for inclusion in this book – some of which I had not seen for years. First, Don Leigh McCulty, who runs the Vivien Leigh Society in America and to whom I sent prints over the years – bread upon the waters indeed; the Mander and Mitcheson Theatre Collection, who rescued many of my big display pictures; Messrs H.M. Tennent, producers of many of Vivien's plays, and Vivienne Byerley, who used to work for the company; Virginia Fairweather, who with her late husband, David, used to be press agent for Vivien and Larry; the Shakespeare Centre in Stratford and all the staff there who look after my Stratford prints so beautifully.

I would like to dedicate this book to David Ball, first my assistant and then my partner, who was there when many of these pictures were taken and indeed actually made some of them.

But most of all this book is for Vivien, and for what I like to call, 'a love affair in camera'.

Angus McBean, August 1988.

10

'I've found a girl with a dream of a face, which will give you no trouble at all.' Ivor Novello had called me on the telephone, insisting that he wanted me to take the production photographs of his latest play. He added, 'she's called Vivien Leigh'.

It was very early in 1936 and I was struggling to make a living as a kind of odd-job man in the theatre. I took portrait photographs of friends and indeed had worked for a time as an assistant to the great Mayfair photographer, Hugh Cecil. But, being thoroughly stage-struck and possessed also of a certain manual dexterity, I thought it more likely that I could survive by making odd bits of scenery and props for the theatre. My first credit in a theatre programme had been a few years earlier when I created medieval shoes for *Richard of Bordeaux*, starring John Gielgud.

That job and a few others had come through three young women I knew, Sophie and Percy Harris and Elizabeth Montgomery, who were making a reputation for themselves under the *nom de theatre* of 'Motley'. At the end of 1935 Motley got the job of designing a Regency costume play for the great Ivor Novello. It was based on a short story by Max Beerbohm and had been dramatised by Clemence Dane under the title *The Happy Hypocrite*. In the fairy-tale plot the libertine Lord George (played by Ivor) falls in love with a little Vauxhall Gardens dancer, Jenny

Mere, and marries her, whereupon his ravaged features are restored to the beauty of the mask beneath which he wooed her.

The high point of the play called for Ivor to wear an exact portrait mask of his noble features, in which he could speak one line and which could then be wrenched off and dropped to the floor. Nowadays, with modern materials, this sort of thing is commonplace in every science-fiction film, but half a century ago it seemed almost impossible to produce a mask which was both strong enough and flexible enough for the job. Oliver Messel, who was very famous for his masks, had already said it couldn't be done and the play seemed impossible to stage.

The Motleys knew that I had been making decorative masks for wall ornaments – they were very fashionable at the time – and asked if I could help. I could but try and so went round to Ivor's splendid flat perched on top of the Strand Theatre in the Aldwych to make a plaster-of-Paris cast of his face. Since the mask not only had to be an exact fit but also an exact portrait, I took along my camera and lights and took photographs of the famous profile from every angle. A few weeks later, having invented a suitable material, the mask was made and it worked. The play could go on.

Then the unexpected happened. Ivor rang me up to say that the photographs I had taken were the best he had had for a long time. Could he use one, cut out like a mask, on the programme and would I take the production stills on the stage?

'But Ivor, bach' – we were both Welsh and had become very friendly – 'I can't possibly, I'm no photographer and I've never done such a thing in my life'. But Ivor insisted. 'It is an unusual play and your unusual pictures might be nice. In any case we shall get the good old Stage Photograph Company to do the big set-ups and you shall do the intimate stuff. No, no, I insist. It will be easy, there are not many people in the cast, and I've found a young girl with a dream of a face...'

I knew the name Vivien Leigh because the new young actress had been noticed in her first performance in a West End play some months before. But of course, when it came to the photo-call on the stage of His Majesty's Theatre a week before the opening of *The Happy Hypocrite*, Ivor got all the attention, not to mention the other leading lady, Isabel Jeans, who was

a big West End star at the time and playing Lord George's former mistress, La Gambogi.

Of that first encounter with Vivien, I remember only that I thought her very, very pretty and charming. Inexperienced as I was, I only took one shot of her solo – how I wish I had taken more – and, alas, even this one precious exposure together with all *The Happy Hypocrite* negatives were lost during the war, so I have had to resort to my press cutting book to recapture my first study of her (*see page 6*).

However, by the end of her first night in the play, I think I had fallen in love with her. Her light, almost juvenile playing of Jenny Mere made a great impression and her childlike purity in the part was entrancing. For weeks afterwards Vivien and her beauty were very much on my mind. These were weeks in which I thought I had 'arrived' at last. Ivor had been delighted with my photographs and they had not only gone up outside the theatre but made the front page of all the many glossy magazines which, in those pre-television days, vied for theatre pictures. I was so proud and used to go and polish the glass on the big pictures outside His Majesty's Theatre or dawdle by the news-stands which had the magazines open at the picture page with my photographs and my name below them. Ivor also declared that he would only use me in future for all his productions, a wonderful boost for a young photographer.

Soon afterwards I accepted one of the very few advertising photographic jobs that I have ever done in my career. Rudolph Steiner the hair-stylist commissioned me to photograph a pretty girl with her hair styled by himself. I suggested Vivien Leigh, who had earned very good notices for her playing in *The Happy Hypocrite*, even though the play was not a great success and had not run as long as expected. He was delighted, because she was a new name in the West End, and she agreed too. By this time the play had closed and she was probably glad of the fee and of the continuing publicity.

The fee was probably only the standard sum for half a day's modelling (by 1951, when I chose an even more unknown Audrey Hepburn out of a West End chorus line for a similar job, it was still only £4). I suppose the Steiner people must have paid Vivien, because I don't remember doing so when she and the famous hair-stylist came to my little basement in Belgrave Road which I had turned into a studio.

Vivien was very patient while Steiner dressed and re-dressed her hair and we made unmemorable small talk between the shots. However, at one point the old man, who was obviously delighted with his model, said while brushing Vivien's beautiful sable locks round his fat fingers, 'I don't really have to do anything. I just brush and it stays where I want it. You are lucky, my dear, you will never have to spend money on hairdressers'.

Perhaps it was from that moment that Vivien took against her own hair. She could be oddly perverse about things that people praised and she appeared to dislike her hair for ever afterwards, always wearing a wig on-stage and often off-stage, when possible.

I sent Vivien some prints of the Steiner hair pictures and she must have liked them. A few months later she rang up the studio and asked if I took 'ordinary' pictures and could I do some in a great hurry. I have no record of the date, but it was the same season that Laurence Olivier was doing his first *Hamlet* and *Henry V* at the Old Vic, which I had already photographed. I do remember that I must have taken the sitting on the Monday or the Tuesday of the week and that I asked her to bring a hat.

She arrived at Belgrave Road looking radiant and bearing a wide-brimmed, black felt hat and I took my usual sitting – eight exposures for six guineas for which I supplied eight finished, retouched, mounted and signed 8″ × 6″ prints. No one ever saw a rough proof from me. Vivien Leigh retouched? The flawless Vivien Leigh? The answer is, yes. The colour-corrected photographic emulsions of today did not exist then and every tiny spot, every broken vein, every freckle, photographed black or nearly black. So why should a photographer immortalize the errant blemish which is here today and gone tomorrow? I never used the techniques of the Hollywood film studio photographers, who completely retouched all character from faces in their pursuit of apparent perfection, but we had become accustomed in the 1930s to the seemingly endless flow of marmoreal beauties from the film world and took note of their style.

It was at the first private sitting in my studio that Vivien asked me if I found her easy to photograph. I replied that I found it difficult to believe that anyone could take a bad photograph of her. 'You'd be surprised', she said. 'I have just had a set taken in Bond Street and I didn't think they looked anything like me. I can't possibly use them and I could have bought a mink

coat with what they cost. But you haven't answered my question.'

So I told her that she had one very small fault. At the right hand side of her mouth she had a tiny raised muscle, which I had encountered before in other faces. It was caused by a small dental misalignment, which made her use her teeth on that side more than the other. This in turn resulted in a slight extra development of the muscle, but I added that I understood that any competent dentist could easily adjust the teeth below and it would disappear.

I was sweating with embarrassment as I was saying this, but she thanked me sweetly and told me that she had noticed the fault herself, especially in snapshots. She said that she would certainly get it fixed. I believe that Hollywood eventually had the treatment done, because in *Gone with the Wind* the little blemish had disappeared for ever.

On Saturday of that week, Vivien rang me up and asked if the pictures were ready. I said that they were and I was very pleased with them. 'Oh, I can't wait', she said, 'could you possibly bring them round to Durham Cottage this evening? Could you come about ten, then we can have a drink and have a look at them? Larry will be in at about half past and he could see them as well.'

It was my first visit to Durham Cottage. From the outside at least it looked an extraordinary survival – an eighteenth-century gamekeeper's cottage in the middle of Chelsea with quite a big garden with apple trees in it, surrounded by a high brick wall.

I was greeted, to my delighted astonishment, with a film-star style cheek to kiss and one of Vivien's death-dealing dry martinis. Would I like to see over the cottage before we settled down to business? I certainly would and found that she had been 'at' the cottage – wall-to-wall apple-green carpet up to the knees everywhere, which was very new at the time.

I was so overcome that I don't remember too much about it apart from two rooms upstairs that were surprisingly big for so small a house, a bedroom with the biggest double bed I had ever seen and a bathroom rather bigger with two of everything, and everything green. Then, me dazed with gin, which I was unaccustomed to, we lay on the green carpet in front of a gas-fire in the sitting-room, looking at the pictures.

Vivien seemed very excited and delighted with the pictures, especially with the one of her in

the big black hat. 'They are wonderful, Angus dear', she said. 'Just what I wanted. Have you read the book?'

'The book', said I, 'what book?'

'Why, *Gone with the Wind*, of course. It's my bible and I am going to play Scarlett if it's the last thing I ever do. You haven't read it? You must.'

She reached out a hand to the low bookcase in the fireplace alcove alongside us and took out a brand new copy, still in its dust jacket. Saying, 'wait a moment', she left me a short time and came back with the book sealed up in a large envelope. 'There you are, that's for you and you must promise to read it. But don't take it out until you reach home.'

At this moment Larry came into the room, clearly exhausted after a Saturday with two performances, and not particularly pleased to see me there. Nevertheless he was very gracious and complimented me on the pictures I had taken of his *Hamlet*.

'And what have you brought Angus here so late for?' he asked.

'Well, he'd taken these pictures of me and was so pleased with them he asked if he could bring them round', Vivien fibbed. She spread them out on the table for Larry to see.

'I must say they are really quite good', said Larry. Picking out one, he said 'But you can't use this one, Viv.'

'Why not?' she said. 'I think it's my favourite one.'

'Well, you can't use it', he said. 'You look like a Javanese tart.'

(In fact the picture is very romantic, she looks pretty and is embowered in apple blossom.)

'What did you want with them so urgently,' said Larry, 'dragging Angus out so late?'

'Oh well, I thought to send them to America with some other things on Monday.'

'If you're still nurturing that silly dream, you can forget it', he said rather brusquely. 'It says in *The Times* today that Norma Shearer has got the part of Scarlett.'

'Yes, I read that', said Vivien. 'But of course she won't play it. She's far too old.'

It almost seemed as if a squabble was on the way. So I said I must be getting home, a taxi was called and off I went.

Of course I couldn't wait until I got home, so I opened the envelope in the cab. On the flyleaf

16

she had written, 'To darling Angus, with love from Scarlett O'Hara', and the date.

My pictures were sent to the Hollywood studio and, she told me later, that it was a picture of her in the big black hat that first caught the eye of Myron Selznick, David's brother, and Casting Director for *Gone with the Wind*. However it was to be a long time yet before she won the part.

In 1938, with Scarlett still uncast, Selznick decided that he had to burn down the Atlanta set for the film. It was cluttering up his back-lot and he needed space to build the Tara set. So Atlanta was burned in December 1938 with Scarlett still uncast. A stand-in played her escaping in the buggy and they used only very long shots.

Vivien, who was in Hollywood at the time with Larry, turned up with him to watch the filming of the burning. She was wearing, she told me, a big black hat.

I believe it was that evening that David Selznick was first captivated by her and so she finally won the part, a virtually unknown *English* girl – by American standards – defeating the concerted efforts of almost every leading Hollywood actress. Certainly I like to think that it was the big black hat which gave the film moguls the idea for that first marvellous view of her in the film, emerging from beneath a huge cartwheel of a hat.

My copy of *Gone with the Wind*, signed by Scarlett O'Hara almost two years before she got the part, alas, was a casualty of the war. The book disappeared in the confusion when my studio was damaged by bomb-blast. Just think what it might have been worth to me now.

The black felt hat that she wore to my studio, or one very like it, turned up again in September 1938 when Vivien was playing in *Serena Blandish* at the little Gate Theatre. This time she added some narrow black ribbons to tie under her chin. Sadly, the negatives for this session were also in that bomb-blast and, search as I may, I have yet to find any existing prints, so once again I have to resort to my press cuttings book, for the picture overleaf.

However, I had photographed Vivien yet again before she made that foray onto the London stage. I had been playing with the idea during 1937 of a series of theatrical portraits with a surreal influence – with the surrealism used mainly for its fun value.

The opportunity arose first when the actress Beatrix Lehman came to my studio for some publicity pictures, a sitter of surreal beauty herself. *The Sketch* magazine was delighted with the

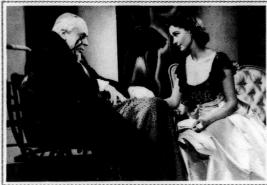

VIVIEN LEIGH
AND HER SERENE BLANDISHMENTS.

"*Serena Blandish,*" now given at the Gate Theatre, is the story of a young girl who is being launched on London Society by the Countess Flor di Folio, and is not altogether the success she deserves to be as she is not hard and acquisitive enough. VIVIEN LEIGH plays the name-part with great charm and point. She is here seen with Sir Everard Pynchon (HEDLEY BRIGGS), who tells her : " When I talk to you I feel myself endowed with your sparkle, your health, your hope, your vitality."

Serena to a Stranger (HAROLD SCOTT) in a bus : " Friendship—that is a subject on which my experience is very wide."

Lord Ivor Cream (STEWART GRANGER) to Serena : " You drink a silent toast to what—to whom—Serena—to myself? "

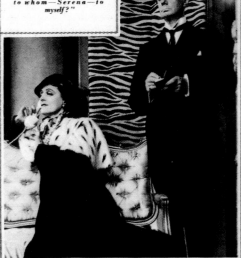

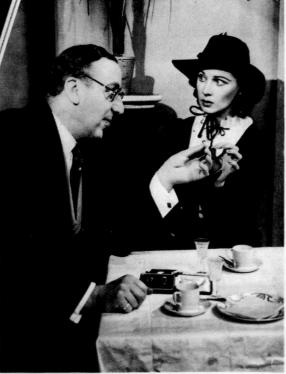

Martin (LAURENCE HANRAY) and the Countess, a flamboyant part admirably played by JEANNE DE CASALIS. He states that " in any emotion it is the intensity which is important, not the worthiness of the object."

Sigmund Traub (AUBREY DEXTER), a diamond merchant, presenting Serena with a diamond ring, hoping that it will attract others to her lovely hand. She is somewhat overwhelmed, as her nature is not a suspicious one.

PHOTOGRAPHS BY ANGUS McBEAN.

A page from *The Sketch* illustrating the second play I photographed Vivien Leigh in. This was called *Serena Blandish*, and opened at the Gate Theatre in September 1938. This is an early example of the series in *The Sketch* which was later called 'From first to last', and sometimes ran to three pages of my pictures, published almost weekly for over four years.

result and suggested that I do one such picture a week. So it happened that my 'surreal' pictures became a feature of the magazine and a tag to my name.

The series had been running for nearly six months when *The Sketch* asked me if I could do four shots of beautiful young people in surreal fashion for a beauty number the magazine planned to run. I had the idea of nymphs and goddesses, with Vivien as Aurora, Tamara Geva as Persephone and various others. In the end time and work made the whole quartet impossible and only Vivien was done.

The feel of the photograph had to be 'Greek' and for the picture I had in mind the dress had to be pretty solid and carved-looking, so I asked Vivien to come along first for a preliminary session, during which I would make the dress out of plaster. (By this time the series had become so well-known and publication on the front page of *The Sketch* was so prestigious and talked-about that I never had a refusal from any model, even if the photograph meant as many as three visits to my studio.)

The Aurora photo took only two sessions but the first was certainly a bit messy. Since Vivien was going to have to hold the same position in the plaster-of-Paris dress while it dried hard, I set up a board for her to lean against and lowered a scenery support for her to hold onto in the raised-hand position that I had chosen. She slipped out of her day dress and I wrapped her in a sheet of very thin and rather expensive white rubber, which protected her from the plaster but moulded to her form. She tied up her hair with a black lace scarf and got into position.

I had roughly cut out the dress in flannelette the previous night and left it soaking in water so, when all was ready, all I had to do was to dip each piece in very sloppy plaster solution and construct it on her bit by bit. We chattered away and laughed as I did so and she never seemed to mind a bit about my hands moulding the plaster onto the contours of her body. Then, when all the pieces were in position, we had to wait for about twenty minutes while the plaster set firmly enough for the dress to be gently eased off Vivien – of course it didn't join up at the back!

When wet the dress was very heavy and easily damaged, but in a week it was dry and extraordinarily light. The following Friday Vivien was expected at 11 a.m. and I got up early and set the picture up.

Often my friend Roy Hobdell painted my backdrops and 'skies' for me, but on this occasion I had decided on cotton-wool clouds. So I painted the back wall of my tiny studio yet again, grading it with sky-like tones, hung up the dress, wired the clouds onto and around it and lit the whole picture before Vivien arrived. The actual photography only took about half an hour – six exposures and the picture was done.

It was published in April 1939 and for some reason the image caused a lot of interest – letters to *The Sketch*, references to it elsewhere at the time. I suppose Vivien was already well-known and popular, but people were also curious how it had been made. So the next week the magazine published a shot of me making the dress on Vivien, snapped while I was working by John Vickers, at that time my general assistant and printer. The shot appeared over John's own name and was his first published picture.

The Aurora picture has certainly continued to cause wonderment ever since. In 1984, when I was photographing for Paris *Vogue*, I was asked where I had got 'that wonderful Fortuny dress' for the picture. 'Oh I made it myself', I replied, 'with a couple of yards of flannelette at *1s 9d* a yard and half a packet of plaster of Paris'. The Parisians themselves just couldn't believe it, quite apart from not knowing what plaster of Paris was.

Forty-five years later the picture was blown up ten feet high to make a giant poster for an exhibition of my pictures on Tokyo's busiest shopping street. It stopped the traffic when it first went up and I used to be vastly entertained to see the Japanese having themselves photographed beside 'Vivu-yan Reigh' ten feet high. Vivien would have adored that.

By the middle of 1938 Vivien must have decided that I should be her official photographer. She went to make the film *St Martin's Lane* with Charles Laughton soon afterwards and somehow she persuaded Associated British Pictures that she and Laughton should be photographed by me in my studio to produce publicity material for the film. I had already photographed her co-star as Captain Hook in 1936, that first wonderful year I had as a theatre photographer, and was to do so again after the war. The studio lent me a length of fake brick wall as a backdrop, but the photographs were not very inspired, I'm afraid.

However, that session led to another private visit by Vivien to my studio. She rang up and

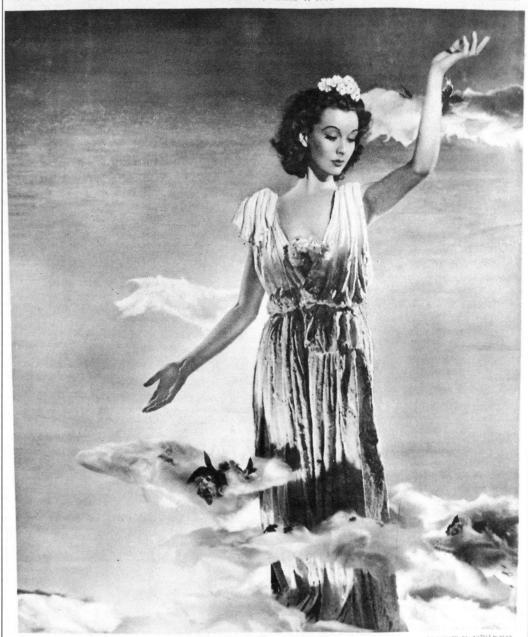

The Sketch

No. 2358 — Vol. CLXXXII. WEDNESDAY, APRIL 6, 1938. ONE SHILLING.

PHOTOGRAPH BY ANGUS McBEAN

BEAUTIFUL GODDESS
OF DAWN.

MISS VIVIEN LEIGH *is here surrealised into the figure of Aurora, Goddess of Dawn. Actually, her star has been in the ascendant for some little time. She is just completing "St. Martin's Lane," the new Charles Laughton film, in which she appears as a street urchin. She is very excited about her forthcoming appearance in "Serena Blandish," at the Gate Theatre.*

Vivien on the cover of *The Sketch* beauty
number as Aurora, 'the Beautiful Goddess of
the Dawn'. April 1938.

asked for another 'ordinary' sitting. She was trying out a new hairstyle, she said. I was aware that she had hated the frizzed-up look that the film studio had given her for *St Martin's Lane* and she arrived at Belgrave Road with hair which must have actually been straightened. I matched the look with a completely uncluttered set of close-up shots, perhaps the most classically simple shots that I ever took of her.

Then, for a while, we lost Vivien to Hollywood and her world stardom in *Gone with the Wind*. Those who knew her were, naturally enough, delighted when it was announced that she had won the part of Scarlett but at the same time as the film came upon us, so did the war.

The London stage closed its doors and my work dried up. My assistants went off to fight and I, thinking that I would be called-up too since I was well within the age of conscription at thirty-five, locked up my Belgrave Road studio and went down to live with an uncle and aunt in their Ralph Wood house in Bath. I still had to live, so I tentatively opened up another studio in the ground-floor flat of the house in Bath and, though photographic supplies were difficult, did reasonably well. The Army and Navy were in Bath, the city was bustling and the London theatre had taken itself out on the road. I began to travel all over the country photographing the shows.

The Oliviers had been away in America with a producton of *Romeo and Juliet*, which sadly never came to this country. Larry came back to join the Fleet Air Arm and Vivien was determined to return to the London stage. Soon it was announced that she was to do *The Doctor's Dilemma*, which would tentatively reopen the Theatre Royal, Haymarket in London, after a brief run in Manchester. I was bidden to photograph the play at the lovely Manchester Opera House.

It was a beautiful production, decorated by Motley and Vivien looked wonderful, as she always did in Motley clothes. Larry must have had special leave because he was there in the audience looking very handsome in his blue uniform.

Next morning, before my photo-call, I came down to breakfast to find Vivien and Larry already there across the huge 'French' dining-room of the Midland Hotel. 'Good morning', called Vivien right across the room in her sweetest voice.

'Have you slept well, Angus dear?'

'Very well, thank you', I replied.

'Have you had your bill yet?'

'Not yet.'

'Well, look at it carefully', Vivien continued at the top of her voice. 'After all we're paying it. Last week poor Lilian Braithwaite (an actress famed among other things for her portrayal of Elizabeth I) found they'd added in a whole dinner for a group of Oddfellows. Wartime staff I suppose.'

We went on to the photo-call, which passed off very well. I had the usual two and a half hours stage time to myself and shot fifty or sixty pictures, having made the notes for the exposures at the performance the night before. Vivien looked ravishing in the Edwardian clothes and gave me one close-up in hat and veil which turned out to be Larry's favourite picture of her. In later life it was always on his desk, even at the National Theatre.

The play turned out to be the last I photographed during the war. The day after I sent off the pictures for the display outside the Haymarket, I received the long-awaited call to four dreary years away. Vivien went on to have a great success in the play when it re-opened the Theatre Royal Haymarket triumphantly and, though she was only ever to do two Shaw plays in her career, she told me that she loved doing Shaw. She said she found his beautiful precise English as easy to learn as the poetry of Shakespeare.

When I returned to London after the war I found that John Vickers, my assistant to whom I had given the Belgrave Road premises and Kodak paper ration when he was invalided out of the army, was very firmly ensconced in both studio and my old practice. I found another place to live and work, in a shop with a house above it in a little Georgian terrace in Endell Street, Covent Garden – then a very run-down area of the capital – and set about converting it to a studio. John Goodwin, then press agent for the theatre at Stratford, sent me Claire Luce, an American actress who was playing Cleopatra in the first season after the war, and those pictures were given a double-page spread in *The Tatler*. I was 'back'.

The Oliviers were either touring or ensconced at the Old Vic, where John Vickers had got himself a contract, but it was not to be long before I was photographing them again. The

23

Motleys had persuaded Sir Laurence, as he had then become, to accept a hand-knitted sweater which they had based on the armorials of Henry V – a role very much in the public mind because of his marvellous film version of the play. Other sweaters were to be marketed and Larry said that he would model some publicity shots if Angus could take the photographs.

So I went to the rehearsal rooms in Islington where he was working and took a series of studies of him wearing the sweater. We had just finished and my new assistant David Ball, who was later to become my partner, was just packing up, when suddenly the door flew open and in swept Vivien, wearing a drop-dead mink which reached right down to the ground.

'Larry, we've got an appointment and I've been waiting. Oh, I'm so sorry, Angus dear, have I interrupted anything? How nice to see you again. How are you, dear?' The film-star cheek was presented for a kiss. 'Welcome home.'

David Ball, looking up from the equipment, said quite spontaneously, 'Good God, it's Scarlett O'Hara.' Vivien smiled and they were introduced.

Not long afterwards both Vivien and Larry came to the new studio, the only time they ever came to the studio together, for some publicity shots for a foreign tour. I took some singles and then a very satisfying double-profile shot which they took round the world with them.

Not long after their return Vivien came to the studio alone for some more publicity shots. She said that the next play she was doing was *Antigone* in Jean Anouilh's new version. She was to have the title role with Larry as The Chorus. She seemed very excited and said that it was her first real chance on stage to show her ability in a great tragic role.

The play was to go on at the New Theatre, but under the Old Vic management. I remember being disappointed because I thought that John Vickers would be asked to photograph it, but a letter arrived soon afterwards saying that they would like me to do it. John's contract had run out and in any case the magazine *Picture Post* had specially asked that I should do it. Vivien, when we met for the photo-call, said she was delighted that I was photographing her in a theatre once again.

It was not the easiest play to photograph, being very static and declamatory, simply set and in modern dress. However, it gave me some very striking groupings, a rare opportunity to take

modern-dress photos of Larry (which he used himself for press purposes for some time to come) and one wonderful head of Vivien (*see title page*).

She was wearing a close-cropped, boyish wig and none of the elaborate eye make-up she sometimes used. I took one shot at a particular line and then felt that I had not quite caught the questioning look that I thought the line called for. So, rather unusually for me, I asked her to say the line again.

Just as I was pressing the shutter, David Ball, who was standing next to me, put his spread fingers over the main light, making soft bars of shadow across Vivien's face. It was a trick he may well have seen me do before, but it gave me one of the strongest pictures that I ever took of Vivien which was to stay on the cover of the French's Acting Edition of the play for almost two decades.

The critics thought she was wonderful in the play and apparently Larry was startled into a new assessment of her acting abilities on stage. Ken Tynan, who was never a fan of Vivien's, admitted her triumph in the role but then ventured that it was to be hoped that Sir Laurence, when he came to do the Macbeth of his maturity, would not allow his sense of courtesy to permit his wife to take the stage beside him as Lady Macbeth. Of course, no sooner was this written, than Vivien wanted to play Lady Macbeth and in due course she did.

It was her next role, however, which to be the second most famous of her life – Blanche Dubois in Tennessee Williams' *A Streetcar Named Desire*, with Larry directing. Jessica Tandy had created the part on Broadway, but Vivien was determined to play the part in England in spite of various difficulties. Her health had not been good at that time (she did not come to the studio for her usual pre-production publicity shots) and, though this made her identification with Blanche even greater, the part of a defeated and worn-out Southern belle was quite a challenge for someone who was then at the height of her beauty.

Vivien was determined to shake off her 'beauty' label since this was interfering with everyone's assessment of her as an actress. So, rather than wear a wig to give herself the bleached blonde hair that the part demanded, she had her own hair dyed and dyed badly to achieve the obviously cheap look that was required. Wearing a wig would anyway have been

hazardous since the rape scene in the play was so violent that it might easily have come off. She also devised an elaborate make-up for the part which caused her to remark afterwards when she first saw my pictures, 'Oh Angus, you are clever. You have retouched away all my real lines and left in the painted ones.'

As so often, the pre-London tour started in the Opera House in Manchester and so David and I went up there for the first night. As we were unloading our gear from the car at the stage door, the stage doorkeeper said that if I had a moment, Miss Leigh would like to see me in her dressing-room.

It was a shock seeing her with blonde hair and the ravaged face of Blanche Dubois nearly complete, but the usual warm greeting and cheek to kiss were there. 'I'm sorry to have bothered you, Angus dear', said Vivien, 'but I wanted a word with you to tell you *now* rather than break the bad news when you come round after the show.'

She explained that she hadn't been very well, which was why she hadn't been round to my studio as usual, and now she went on to the bad news. The whole world's press seemed to be in Manchester – 'Come, I suppose, to see me play a wicked woman' – and she continued to say that she couldn't face two photo-calls. Although she realized how difficult it would make it for me, the rest of the photographers were going to have to be allowed into my photo-call.

It was rather a blow, but I had to say that I didn't mind in the least. And it was just as well that she had decided to see me before the show. Afterwards there was such a crowd to congratulate her that it was decided she should greet them on stage rather than in her dressing-room and the party would follow. As we came onto the stage, past the prompt corner – always a darkish spot – Vivien was looking in our direction. She called out, 'David, David, how wonderful', and arms outstretched, came straight towards us. David Ball, thinking his moment had come at last, was about to respond when Vivien sped straight past him straight into the arms of David Selznick, the Hollywood producer of *Gone with the Wind*.

The photo-call the next day was grim. I faced the world's press photographers and told them that the call could only run the usual two and a half hours, that they must work round me and keep out of my way. Moreover they could use no flash but had to make do with my lighting.

Luckily there was only one set and because there was only a small cast the scenery had been placed far downstage, pushing me right into the footlights with my camera.

We had got about halfway through the play to the rape scene, where Stanley Kowalski forces her back across a table (which had to be fixed to the floor because of the violent way in which this was done). Bonar Colleano played the Kowalski part on stage with Vivien and was, to my mind, much better than the inarticulate but physically magnificent Marlon Brando in the later film version.

We were already running a little late, held up unavoidably by the other photographers, when, in stepping back to get the distance for the shot, I actually trod on another photographer who was apparently trying to get his picture from between my legs. At this point I finally lost my temper. Asking Vivien and Bonar to relax a moment, I turned to the crowd and said that they must have enough pictures by now and that they should stop immediately because it was unfair to Miss Leigh and the rest of the cast.

Somehow I got to the end of the call only a few minutes over-schedule. Having developed the negatives I was delighted to find a very good set of pictures, and the moment that the production moved to the Aldwych Theatre I hurried there with the finished $10'' \times 8''$ prints to find final rehearsals in progress.

Vivien, as always, went through the prints slowly and carefully. There were perhaps forty-nine or fifty of them and she put only one, face downwards, aside. Oh good, I thought, only one out.

She smiled and made her joke about the painted and the real lines. Then she turned the discarded print over. To my dismay I saw it was a very good picture and the very one that I took of the rape scene after clearing the photographers away – the one of Blanche being forced back over the table.

Vivien said that she knew it was an important moment in the play but she hadn't been well and it showed her looking much too thin. Indeed, in the struggle her blouse had been torn, revealing quite a lot of chest, and my customary harsh, dramatic lighting had caught her ribcage showing under the skin. 'Please don't use it,' she said and tore off the corner of the print – the

accepted way of showing that a particular print had been rejected. I was disappointed, but could only agree with her and promise that the picture in question would not be used.

A few days later the display photographs went up outside the theatre and the first night came and went. Vivien played the part with such intensity that she won brilliant reviews and it was clear that she was the only choice for the film which was to follow. (To my mind, she was much more moving on stage than on film in the role, but that was not really her fault and she won her second, very deserved Academy Award for Blanche.)

On Saturday morning after the first night at the Aldwych, my secretary said that Binkie Beaumont, head of the play's producers, H.M. Tennent, wanted to see me in his office. I found Binkie in an uncharacteristically grim mood. He told me that 'Miss Leigh' would like to see me in her dressing-room between the matinée and the evening performance. I thought that the 'Miss Leigh' and not 'Vivien' was odd, and asked him if anything was wrong. He would only say that it was my problem, he wanted no part in it. 'Be careful Angus, she is in a great taking', was his phrase.

I spent a miserable time waiting for five o'clock when I set out from Endell Street for the Aldwych. The stage-doorkeeper told me that Miss Leigh was expecting me.

She was sitting in the comfortable chair that she always had installed in her dressing-rooms – she never left the theatre, to my knowledge, in the hours between the matinée and the evening performances – and gave me no time to greet her.

'Sit down Angus, it was good of you to come so promptly, but this won't take very long', she said coldly. 'I thought you might like to have that', she went on, waving her hand towards her still-lit dressing-table.

'That' was a copy of the weekly magazine, *Everybodys*, a large-circulation, one must say downmarket, publication of poor quality. There on the cover, luridly hand-coloured as was their fashion, was a reproduction of the picture she had torn. I was thunderstruck, but she gave me no chance even to attempt an explanation – not that I had one.

'I am very surprised and hurt that you have done this', she said curtly. 'I expressly asked you not to publish this picture and here it is. I'm afraid, Angus, that this is the end of our friendship

and you will never photograph me again. Go now, I want to rest for the evening performance. Oh, take this', she added as I was rising to go, 'you will want it for your press cutting book'.

So I went back to Endell Street and spent a miserable weekend. I looked everywhere for the torn print but couldn't find it. I felt it must have been sent accidentally to Vivienne Byerley, Tennent's press agent, with the rest of the prints. It was a very dramatic picture and Vivien had torn off only a very little corner of it. Perhaps that was how the mistake was made. Or perhaps Vivienne Byerley, who was then fairly new to Tennent's, didn't know how rejects were marked. I tried to ring her but she was away. The only thing to do was to wait until my staff came in on Monday morning.

The moment they arrived I asked Miss Burrowes, my secretary, if she knew what had happened. Had it been sent off accidentally? All the staff knew that it had been rejected and Miss Burrowes quickly provided the explanation. Thinking it was a pity that the print had been rejected and thinking she would please me she had given both the print and the negative to Miss Avala, my chief retoucher, to see if anything could be done. She hadn't told me because she knew how upset I would be if anything had happened to the print.

There was only one answer. The *Everybodys*' picture couldn't be mine. I went to Miss Avala, who was actually working on that negative at that moment. I asked for the print and discovered that it had been in her private drawer all the time. Hurriedly I took it back to my desk and laid it alongside the *Everybodys*' cover. The two were extraordinary alike – the lighting, after all, was mine – but the angle was slightly different. The *Everybodys*' picture was taken from a lower viewpoint but this was not obvious because of the colouring and bad printing.

The picture, I suddenly realised, must have been taken by the photographer whom I had trodden on when I was fixing up my shot.

I could have cried with relief. Vivien would surely be able to see the difference. But I waited until Tuesday, until Miss Avala had finished her long and difficult task of retouching Vivien's ribs. Then I made a fresh print and took it, still wet, along with the old, torn print and the magazine, straight round to Binkie Beaumont's office. He immediately saw the difference and suggested I take them to Vivien or ring her at Durham Cottage.

'No please', I insisted, 'won't you ring her for me? She will listen to you and might well refuse to see me. I can't possibly explain this on the phone.'

So Binkie rang and I went to the Aldwych Theatre before curtain-up that evening. Silently I went into the dressing-room and laid the discarded print and the magazine cover side by side under the brilliant lights of the make-up mirror. I told Vivien that the torn print was the only one made from the negative and that it had never left my possession, it was obvious that the two images were different and that the other must have taken by the other photographer.

Vivien, who must have been under some strain because of the demands of her role and also, perhaps, my imagined treachery, suddenly burst into tears and flung her arms around me. 'Oh Angus, dear, can you ever forgive me? I should have known there was some explanation. I am so sorry. After all it was my fault, that beastly photo-call I forced on you. I should have known you would never have used a picture like that. I will never let it happen again.'

I had never seen Vivien lose her calm and dignity before, and I was a little relieved when it was quickly over and I was able to produce the new print with a flourish, still limp from its cocoon of blotting paper. Miss Avala, with her astonishing skills, had done marvels. There was the expanse of chest, smooth and without so much as a shadow of a rib. Vivien was able to laugh and delightedly passed the print for use.

The play ran for months in the West End and then she went to America to make the film, so I saw nothing of Vivien for almost a year. On her return something had to be done for Larry's own theatre company, Laurence Olivier Productions, which had taken a lease on the beautiful little St James's Theatre. The company's first production without Vivien had been a success, but the second had been a flop.

Vivien told me that at an L.O.P. meeting Larry had at first suggested that they perform *Caesar and Cleopatra* by Shaw. She had already played the sixteen-year-old Egyptian queen in the film in 1945 with Claude Rains, but she hadn't remembered the making of the film with much enthusiasm and said that she would prefer to play Shakespeare's *Antony and Cleopatra*.

Somebody else first suggested the idea of playing the two plays in repertory, only to be told by Larry that the idea was far too expensive and that he didn't want Vivien undertaking such a

taxing double. Shortly after that they went off for a holiday to Paris with nothing decided.

Vivien told me that she was so fired with the idea of playing the sixteen-year-old Shavian and then the thirty-four-year-old Shakespearean queen on alternate nights that she worked on Larry. She apparently pointed out that he had much the more difficult task playing the dry Caesar and the fiery Antony. 'After all', she joked, 'it's much less work for me. I'm playing the same woman and many plays call for a much bigger jump in age.' She also inspired Roger Furze, L.O.P.'s designer, to come up with the same simple set of some huge Egyptian pillars and a sphinx on a revolve for both plays and pointed out that the coronation robes for Cleopatra in the Shaw could be used again with more jewellery for the asp scene in the Shakespeare play. Most tellingly of all, she pointed out that everyone who saw one play would be bound to pay again to see the other.

However, Larry hardly needed much persuading and before many weeks David Ball and I were travelling up to Manchester for what had to be a double session of photography on two separate days after two separate first nights. The Shaw was put on first to a crowded theatre. It is, from the audience's point of view, perhaps the more difficult play, but it was wonderful. Larry was revelling in the kind of character role of which he was a master, and he put across Shaw's long arguments as if they were love speeches.

But Vivien was extraordinary. She became a little teasing girl again, full of the wisdom that Shaw gives to the childish lips of his queen, and the flirtatious charm of someone half her real age.

The following night the acting was equally impressive. Larry was a beautiful Antony and she was quite simply the best Cleopatra I have ever seen, or photographed – and I have photographed many in what is often called Shakespeare's greatest female role. Looking tall and graceful with extra jewellery and a full hieratic make-up adding extra splendour, her performance was rich and so mature. Even her voice was a whole octave deeper – the result, I had heard, of voice lessons.

The photo-calls both went like a dream. The whole company were euphoric because the audiences had made it quite clear that they had a triumphant success on their hands and, as

usual with Vivien, all her co-workers were a little in love with her. At the Caesar call there was one funny incident. Vivien was reclining on a tiny chaise longue and I asked if the little couch could be moved for a single shot I was setting up of her, to make a more dramatic picture. A hefty young Manchester scene-shifter picked up the couch, complete with Vivien, and put it gently in front of the group of pillars, where I had indicated, and then, realising what he had done, stuttered, 'Oh, I'm sorry Miss Leigh – I shouldn't have done that.'

Vivien, still clearly in character as the sixteen-year-old queen, gave a little laugh and said, 'Such muscles. We must fit you out with a loin-cloth and leave that in the play.'

The Antony call, the next day, did teach me one sharp lesson. When the call began Vivien came out in the full Egyptian make-up that she had gone to great lengths to copy from tomb murals, including one that was said to be of Cleopatra herself. She turned, as usual, to show herself off to me and ask me if her make-up was all right for the camera.

She looked of course wonderful, but, as I had been asked, I said that perhaps there was one too many eyebrows. There seemed to be at least three to each eye. 'Oh', said Vivien, 'I suppose it is a bit heavy for the camera. I'll fix it. I won't keep you a moment.' And off she went.

We waited about half an hour and she came back, as far as I could see, quite unaltered. 'Is this better, Angus?' she asked, with a bright smile. That was the last time I have ever criticised an actress's make-up or appearance, even if asked!

The two Cleopatras also marked the first time that I used the device of the close-up double profiles. People often think that it is a trick done by montage because it is a very difficult shot in which to get sufficient depth of focus. However, it can be done in one shot if the two participants stand face to face, clasped to each other, and then turn their heads to the appropriate position.

Not a print from either session was torn when they were shown to Vivien and Larry, and I think my pictures show the extraordinary transformation she managed between curtain-down one night and curtain-up the next. The plays opened at the St James's Theatre in May 1951 and were such a great success that they transferred to the Ziegfeld Theatre on Broadway. The plays had to be re-photographed in New York by someone else because there were quite a few

changes of cast, but Vivien had no singles of herself taken, insisting that mine should be used for the Broadway productions.

When the Oliviers returned to England their beloved St James's Theatre was under threat of demolition by developers. There was a great fight to save it and even a debate on the subject in the House of Lords. Vivien went to the debate and when one of their noble lordships said that the theatre had no historic or architectural value, the fighter in Vivien overcame her dignity. She shouted over the rail of the gallery that she had to protest, the theatre must be saved, and carried on shouting in the stunned silence until she was forcibly ejected.

In due course she was fined for breaching the peace and for a moment it looked as if all the furore that Vivien caused might save the theatre. Even Sir Winston Churchill put up money for her fight, but it was to no avail. The theatre was eventually pulled down and a faceless office block now fills the space. Since then people have said that Vivien's outburst was an indication of her increasingly manic condition. I wonder. Vivien was always a great fighter and she felt strongly about things she really cared for.

Certainly she was ill with a flare-up of tuberculosis before her next appearance on the West End stage with Larry. It was Coronation Year and the play chosen was a light comedy which would not make too great a demand on her health – Terence Rattigan's *The Sleeping Prince*.

I thought she was enchanting in the play, so fresh and beautiful and she gave the lightness she had given to the young Cleopatra to the part of the young showgirl, Mary Morgan. It was difficult to believe that she would celebrate her fortieth birthday when the play opened in London. She was once again playing a blonde – though this time she wore a wig.

David and I went to see the play in Manchester to photograph it and called on her in her dressing-room as usual after the first night. The place was embowered in flowers and she had taken off her wig and make-up and still looked remarkable. TB, apparently, has the effect of thinning and stretching the skin, so that it looks like silk; but she had lost a lot of weight.

She seemed delighted to see us and said so. 'You at least can make me look twenty again', she said with a laugh as I kissed her. I thought she had never looked more beautiful, but said nothing except to praise her performance, knowing how she hated anyone making remarks

33

about her beauty. Vivien went on to say how lucky she was that she was playing a part which called for plenty of eye make-up – 'Making the job easier for you, dear Angus' – a sly joke about our last encounter in Manchester.

That New Year's Eve, Neil (Bunny) Roger gave his customary fancy-dress party, setting the theme as royalty. My rather large party went as the Perhapsburgs – there was, I remember, Hyacinth and Lowercinth and I was, inevitably, McHapsburg. I forget most of the details of my costume, but I do recall that I wore a rather full wig – Michael Redgrave had inadvertently left it behind at my studio the day before when he came to be photographed as Captain Hornblower for a film he was making – and I topped off the regal trappings with a paste tiara, a bit of studio 'tat'.

It was almost half-past eleven and the party was in full swing when the rumour went round that Vivien Leigh had arrived. She swept in, superb in a grand sweeping bare-shouldered gown of heavy ivory satin by Victor Stiebel – the kind of elegant simplicity which costs a fortune. She flung herself into the party and danced like a madwoman with everyone, including me, and I am a filthy dancer.

In the middle of one of our dances she suddenly said, 'Your crown is much grander than mine, let's change.' So, lit up with champagne, we did. 'What fun', she said, 'we must exchange tiaras every New Year's Night.'

At about four o'clock in the morning my party left, exhausted, leaving Vivien still dancing with undiminished vigour, the Stiebel dress torn and soiled. Inevitably there was talk about the fact that here she was out on New Year's Night alone, without Larry, and remarks were passed that all was not well between them.

When I got home from the party I stumbled into bed, having ripped off my clothes, only to be woken by the telephone in what seemed the next minute. 'Lady Olivier's maid here', said the voice. 'When Lady Olivier came home last night, she found that she had on the wrong headpiece and seems to remember that it was yours.'

I rushed upstairs and there, tangled in the wig, was Vivien's beautiful little diamond tiara. I hurried back to the phone with the good news and was thanked profusely.

'Oh, her Ladyship will be pleased – I think it must be rather valuable, I'll send round for it immediately. I'm sure her Ladyship will want to thank you personally but she came in rather late last night and hasn't even had her breakfast yet.'

Of course Vivien did thank me, with another reference to next New Year's Eve.

A year later we didn't have the chance to exchange tiaras but 1955 turned out to be a vintage year for our photographic collaboration. It was announced that the Oliviers were to join the Stratford Theatre for the season to play in *Macbeth*, *Twelfth Night* and *Titus Andronicus*. It was a big decision for the pair of them, since they could have been earning so much money in films, to work for the year on such low wages, but clearly they both felt the need to prove themselves. Vivien, despite all her Academy Awards for films, still felt she had to prove herself as an actress on stage. She had told me several times on her visits to my studio of her ambitions to play all the great classical parts for women, and comments such as Mr Tynan's only served to drive her on.

I went to Stratford every year anyway to photograph the productions because, ever since my lucky break with Claire Luce, I had been official photographer to the company. So it was double pleasure for me to be photographing the Oliviers as well.

In their digs in Stratford Vivien asked me to do yet another informal sitting for hand-outs to the press. The result was a picture which she said for years afterwards was her own favourite of all the ones I had taken of her – a quite straight shot of her leaning forward onto a bent back hand. Her choice was all the more remarkable since she very rarely allowed me to take out-of-character shots which included her hands.

I could never understand these phobias about parts of her body. I have already mentioned her feelings about her hair, but she also felt that her 'paws', as she called them, were too big and ugly. They were certainly not the exquisite long-nailed appendages of some women, but they were fine actress's hands which she could use to great effect, and she couldn't have expected them to have been anything else since she did a great deal of heavy gardening work in her various gardens. At other times she would complain about her neck, saying that it was too long, or about her legs, that they were too thick, too fat, too short. All nonsense, in my opinion.

Vivien's performances in the three plays were, to my mind, triumphs. The first to open, her Viola in *Twelfth Night*, gave her a new kind of bitter-sweet comedy to work on, and she made a magical young thing of the girl washed up on the beach in Illyria, and a delicious girl playing a boy in the court of Orsino.

In *Titus Andronicus* the part of Lavinia, who has her tongue hacked out and her hands lopped off after only one scene, is a fairly unrewarding and difficult one to play. But by using mime she gave a superb performance which provided me with some more wonderful pictures. Only in her first scene where she had to wear a very correct Roman matron's wig, which she didn't much like, was there the slightest hint of unease about her appearance.

Her Lady Macbeth has divided critics, but I think that, on balance, the judgement has been that it was a very great performance. I have seen and photographed a dozen *Macbeth*s, and I think that hers was the finest and most moving of all. Vivien came nearest of anyone, in the very short time that Shakespeare gives Lady Macbeth, to make us understand the iron ambition and the evil which seduces an intrinsically good but weak man to screw himself up to such deeds of terror and blood. Her stunning beauty made her all the more terrifying. The sleepwalking scene was so moving, and it was only afterwards that one realised that she had played the entire scene cross-eyed.

Directly after the Stratford season was over, Larry wanted to make some money and it was suggested that he should film *The Sleeping Prince*. The part of Mary Morgan, however, did not go to Vivien but to Marilyn Monroe, who was almost fifteen years Vivien's junior and a big American star. The reason that has been advanced for this is that Vivien, in her forties, could not get away with playing a twenty-year-old in close-up on films. However, it is just possible that Larry did not want to have to pit himself against his wife on screen.

There are those who feel that Vivien had more presence on film than Larry and that, having given two of the greatest female performances of all time on screen in *Gone with the Wind* and *A Streetcar Named Desire*, her name was even greater than his in films at that time. Certainly it is interesting to note that, although they acted together so much on stage, they never made a film together after *Lady Hamilton* in 1941.

36

In the event *The Prince and the Showgirl* (as the film version was renamed) went ahead disastrously. Monroe was hopelessly neurotic about everything, and she and Larry did not get on. He, exasperated finally by her half-digested method acting and her constant lateness on set, took to referring to her as 'that troublesome bitch'.

Curiously enough, my own involvement with the Rattigan play had not quite ended. Marilyn Monroe's press agent one day rang up my studio and ordered two copies of every one of my pictures of *The Sleeping Prince* which showed Vivien. It cost her a fortune.

Larry meanwhile, perhaps feeling a little guilty about Vivien and the film, persuaded her that she should perform in a new Coward play, *South Sea Bubble*. I can't help feeling that he can't have thought it a very good play but it did contain some funny lines. And, as Vivien herself reminded me when she came to the studio for the usual pre-show publicity shots, she played, for the first time ever, a perfectly ordinary, modern-day, smart English lady, which in real life she was. The pictures proved to be rather nice, showing her in crisp tropical linens, but she made protestations that the short dresses showed off her hated legs.

When *The Prince and the Showgirl* eventually appeared, *South Sea Bubble* was still running rather well, thanks to the combination of Leigh and Coward. Vivien stole all the attention from Marilyn Monroe when, at the first preview of the film, it was announced that she was expecting a baby.

She should perhaps have given up her part on the West End stage immediately, for not long afterwards she lost the baby. How might the history of the Oliviers have been different if she had not. Already there was gossip that all was not well between the two of them.

However, the following year, 1957, they plunged themselves into a long European tour of *Titus Andronicus*. Since it was the same production and the same cast, no more photographs were needed, but nevertheless Vivien came to the studio for the publicity photographs. She shrugged off the subject of her miscarriage and told me that when they came back from the tour she would be doing a play by Giraudoux, *Pour Lucrece*, then being translated from the French by Christopher Fry under the title *Duel of Angels*.

In fact, not long after the tour of Titus ended, the Oliviers began to go their separate ways

37

and *Duel of Angels* did not open until a year later. Larry had nothing to do with the play and did not even go to see it. The great French director Jean-Louis Barrault directed it and the gowns were by Christian Dior.

The story was the age-old one of the battle between good and evil and for some time Vivien could not decide whether she should play the good or the bad angel. I could not imagine why. The Dark Angel was much the stronger part and she looked wonderful in black. When the play opened at the Apollo Theatre in April 1958 Vivien's blazing performance made her much younger co-star Claire Bloom look pallid by contrast.

My own contribution, however, was nearly fraught with disaster. I had taken what I thought was a very good set of pictures and shown them to the two ladies. To my dismay I discovered that nearly half were rejected with their corners torn. Someone jokingly suggested that clearly Claire had rejected all the pictures where Vivien looked more beautiful than herself and Vivien had discarded all those where Claire looked younger – so it was a wonder that I had any left at all for the displays. However, luckily for me, one early critic of the play wrote that Vivien was 'breathtakingly beautiful', and I was able to persuade her later to pass quite a few more photographs.

The play eventually ran for more than a year and Vivien had it written into her contract that she could be flown to Paris for a new fitting for costumes by Dior whenever the originals got shabby. She did too.

It was during this run that the Oliviers split up completely. Notley Abbey, their house in the country, was sold and Vivien bought a flat in Eaton Square. Soon there occurred a trifling but illuminating little example of her unhappy state of mind at having lost Larry.

David and I bumped into her one day and she declared that she hadn't seen anything of us lately. Would we like to come to tea next Friday? She had people coming and would we like to see the new flat?

We went at four o'clock on the appointed day, to find quite a number of people there but no sign of tea. Vivien was immaculate in a sort of dressing-gown and apparently a little mystified as to why we were all there. We were all shown round the new flat, admired the Bonnards on the

wall and then were offered drinks. 'A bit early, dear', all of us murmured and drifted, bewildered, away.

I had intended not to pass comment on the Olivier divorce but feel I must, with another example of how it affected the pair. It was 1960 and just after the divorce. Vivien was away on Broadway with *Duel of Angels* and, fatefully, her future companion Jack Merivale was in the production. She had, as usual, come to me for the pre-transfer press shots.

Larry's agent rang me up and asked if I would do a commercial advertising job for Larry, nothing to do with the theatre. I said, yes, of course. I was quite pleased because I hadn't seen him for ages and also, when we had last spoken, he had sounded a little distant. When he arrived he explained why, saying, 'Well, Angus, you always loved Vivien so much and I have found our friends have split into two camps. Quite a lot of people have made it quite clear that they blamed me, especially when taking Vivien's health into account.'

I protested that I didn't take sides in things that were none of my business. 'Besides I love and admire you both dearly, but thank God that I don't have to live with either of you.'

I had always been a little in awe of Larry but suddenly I felt on quite different terms with him. The next moment he was explaining that he could no longer live with Vivien's indomitable energy, her seeming lack of a need for sleep and her terrible tantrums, and so he simply had to call a halt to it. 'I find, increasingly, that to do my work properly I need my rest. But she just carries on as if she had not time to get it all in and can work, work, work as well.'

The pictures he had come to have taken were for a rather misjudged venture – 'Olivier Cigarettes'. He was a little defensive about it, saying, 'Jean de Reske did it, so why shouldn't I?' So we got on with the job and I took all the pictures, including the silhouette of Larry with a smoke curl rising above him, which was used on the packet.

A year passed before I photographed Vivien again. She was to do a long foreign tour of *Twelfth Night*, *Duel of Angels* and *La Dame Aux Camelias*, all new productions and all with new designers. She was so delighted with one of the Loudon Sainthill dresses – the wedding dress for the end of *Twelfth Night* – that she rang up and asked me to go to Old Vic and take a quick picture of her wearing it while they were rehearsing.

I took just one shot, using a drape of scrim to disguise the rehearsal stage. Vivien looked glamorous, but slightly sad for a bride and I am very fortunate that this one picture survives from that occasion (*see opposite*). She promised that I should photograph her in the other costumes as soon as they were ready, but they were never finished before the company set off around the world.

Sadly, this turned out to be the last time I photographed Vivien on a stage, but it was by no means the last time I photographed her. Once she came to my studio and I took the evocative double profile of her which is now in the National Portrait Gallery.

Another time she came to see me when a new specialist had put her on steroids after a disturbing flare-up of her TB, saying that she was too thin. Vivien complained that she had put on weight in all the wrong places and claimed that the resultant pictures made her look too fat.

Only a few months later she rang up to say that she was much better and had lost a lot of weight. Could I go along to her flat to do the sitting since she could then show off the new dresses which she had bought to celebrate the new slim figure? The best picture from this session was perhaps one with a feather boa, which she said she was wearing for a mad dance scene in a film that was in preparation, *The Ship of Fools*. The film, when it came out, showed just how brilliant she could be on screen, even in a cameo performance.

In May 1965 I was booked by H.M. Tennent to photograph Vivien in Manchester in a new play, *La Contessa*, which was to come to the West End. It was based on the extraordinary life of the Marchesa Casati, the great turn-of-the-century beauty who ran through several fortunes. The play, however, was not a success and closed in Manchester before I was even able to photograph it.

The following year Vivien went off to Broadway to play in the musical *Ivanovich*, and it was not till June 1967 that she rang again.

She hadn't been to the studio for a while as she hadn't been very well, but she had a new play, *A Delicate Balance*, by Edward Albee, which was soon to start rehearsals. I would be photographing the play of course, but she wanted some press prints. 'I am fifty-three now', she told me, 'so I just want you to take some ordinary Mrs Bloggs of Nuneaton shots. The part in

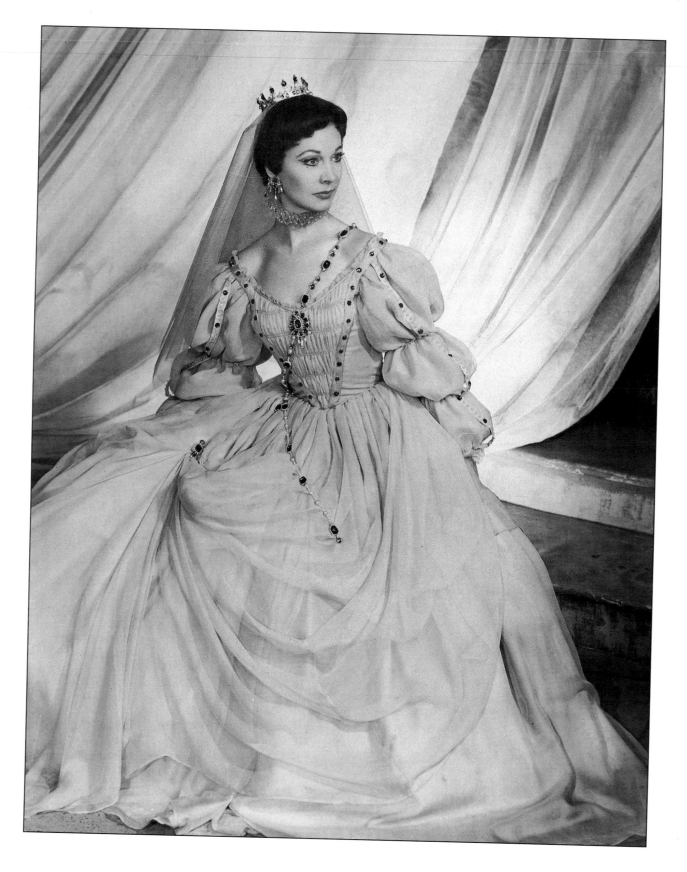

Vivien as Viola in *Twelfth Night*, wearing the
beautiful wedding dress mentioned opposite.
This was a single shot taken on stage at the
Old Vic.

the new play isn't at all glamorous, so the glamour-puss stuff is out. But because it will be so very dull for you, and it would be amusing to see if we could still do it, I will go to Stanley [Hall] and be all wigged and eyelashed up. After all, a lot of plays go from eighteen to eighty these days, and it would be nice to do. Just a couple of those and then I will take it all off and you can take me as Mrs Bloggs.'

I bought orchids for the glamorous shots and Vivien arrived and signed the visitors' book for 4 June, looking amazing – white furs, a full stage make-up by Stanley Hall which used very little foundation but the full treatment for her eyes, and a sleek brown wig. She could have gone straight onto the stage and played Camille as she was.

She let me take just two shots and then said that was enough. 'After all, we won't be able to use them. And now I'll go and wipe it all off and put on an ordinary street face for the really boring job.'

It was the first time she had been to my new studio in Islington – I had had to move from Endell Street. I was glad to be able to show her over a newly-decorated changing-room.

She had warned me that it would take a little while to do, but in about twenty minutes she came out – furs gone, revealing only the impeccably-tailored little black dress, her own beautiful still-dark hair combed out and her eyes looking completely different. The false eyelashes were gone and her own were discreetly made-up with a little mascara.

As always, she said, 'Will I do, Angus dear?' I looked at her carefully, as a photographer must, and could see very little evidence of the serious illness she had lately been through. Even the hated neck, that usual giveaway, showed little of the ravages of time.

Her eyes were sad, however, and what has been described as her 'little cat smirk' had disappeared from the corners of her mouth. I found myself taking more than my usual eight shots. It was difficult to get any of the usual sparkling life or the tranquillity of earlier sittings and I ended up taking twenty poses.

However, when I went round to Eaton Square to take her the finished pictures, she seemed pleased. She put aside the two glamour shots with a little chuckle and went through the rest rather thoughtfully. We were sitting on a carpeted floor as we had on a similar occasion so

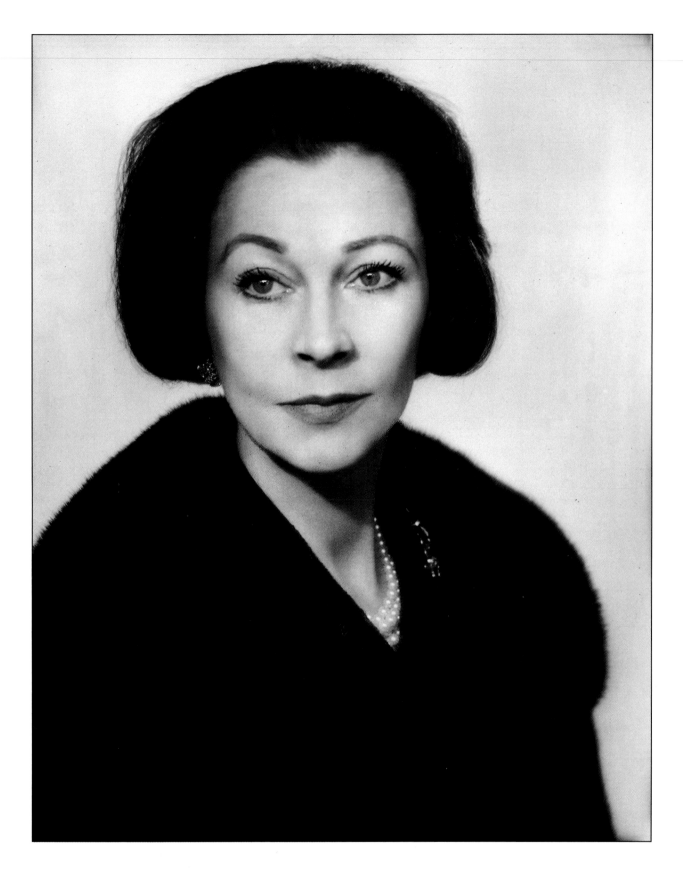

One of the pictures from the last sitting in
1967. This is one of the more
straightforward 'Mrs Bloggs' shots.

many years before and she did as she always did – carefully scrutinized each picture without comment and then laid them aside in a neat pile. Then she went through them again and picked out six. She said she would have a couple of dozen of each but asked me not to destroy the negatives of the rest. 'We'll put them away and I might be glad to use them in a couple of years time!'

About three weeks after this I heard that she had had another flare-up of her TB and was actually having to rehearse her new play from her bedroom. I wrote to her, commiserating with her and hoping that she would soon be well. By return, a card arrived from Vivien.

It was one of those silly French postcards with an awful hand-tinted photograph of a young couple, with *Bonne Année* printed across one corner. The card said 'Thank you Angus, darling. I will soon be better and seeing you to be photographed as arranged.' (The play was to open in Manchester and I was booked for the first night and photo-call.) She had added a P.S., 'Why can't you take beautiful pictures like this card?'

Later that morning I was sitting in the kitchen having coffee when the music on Radio Three stopped and there was a news-flash, 'Vivien Leigh, the actress, was found dead in her bed this morning'.

'Age cannot wither her, nor custom stale
Her infinite variety.'

Antony and Cleopatra
Act II, Scene II.

44

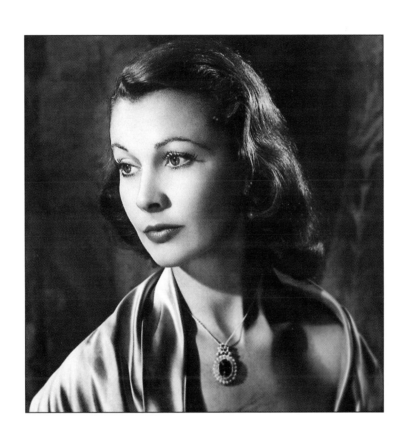

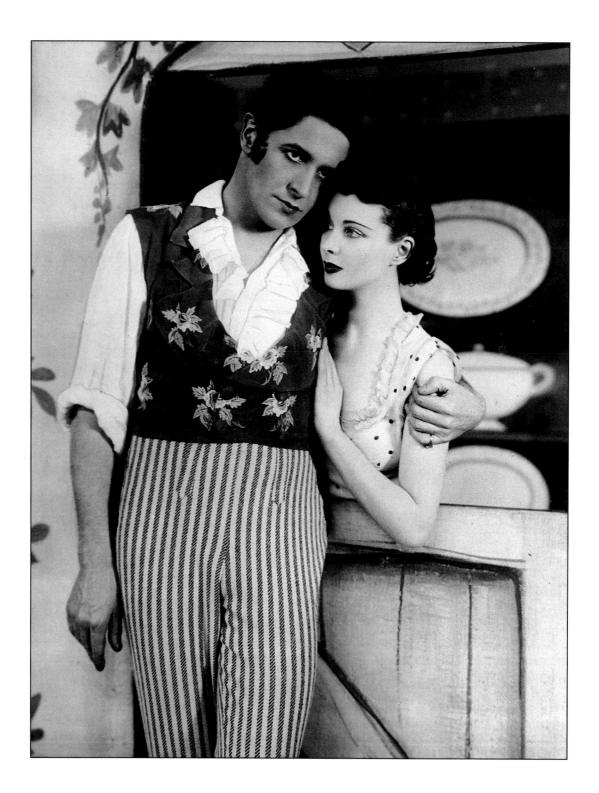

Vivien with Ivor Novello in *The Happy Hypocrite*, her second play. This was taken in April 1936 in Her Majesty's Theatre – my first pictures taken in any theatre and therefore the beginning of my career. It was also my first meeting with Vivien.

(*previous page*) A portrait shot, taken in the studio in 1950.

One of the very few times I ever did an advertisement was for the hair-dresser, Rudolph Steiner. I said I would do it if they agreed to use a pretty girl I had lately photographed on the stage. It was Vivien, of course, and this must have been her first visit to my studio. She seemed quite pleased with the three guineas for half a day's work, which was the going rate for the time. It was 1936.

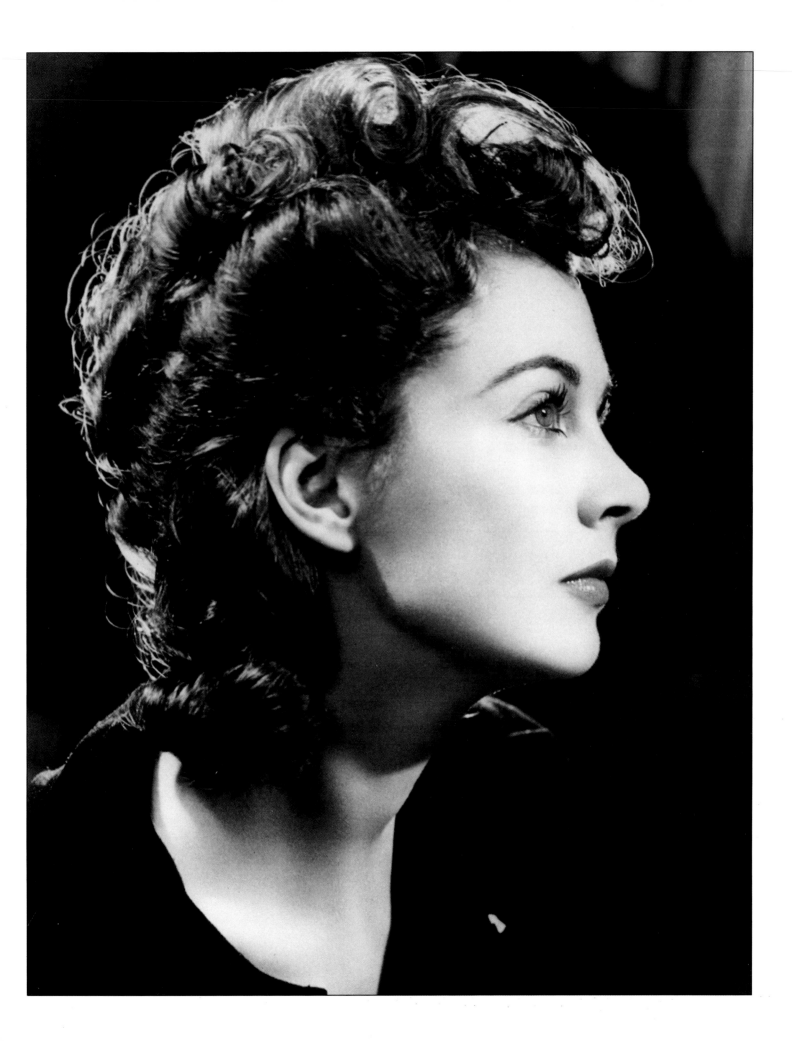

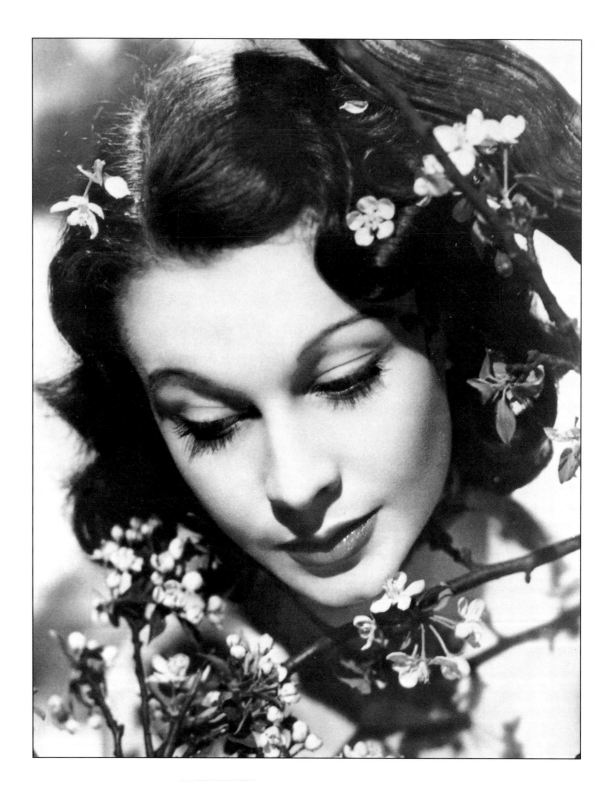

Taken, along with the picture opposite, in
the studio in 1937. This photograph was
reproduced in *The Tatler* in 1939,
announcing that Vivien had got the part of
Scarlett in *Gone with the Wind*.

(opposite) The second version of my favourite
picture (*see page 8*). In both these shots she is
wearing clothes from the play,
Serena Blandish.

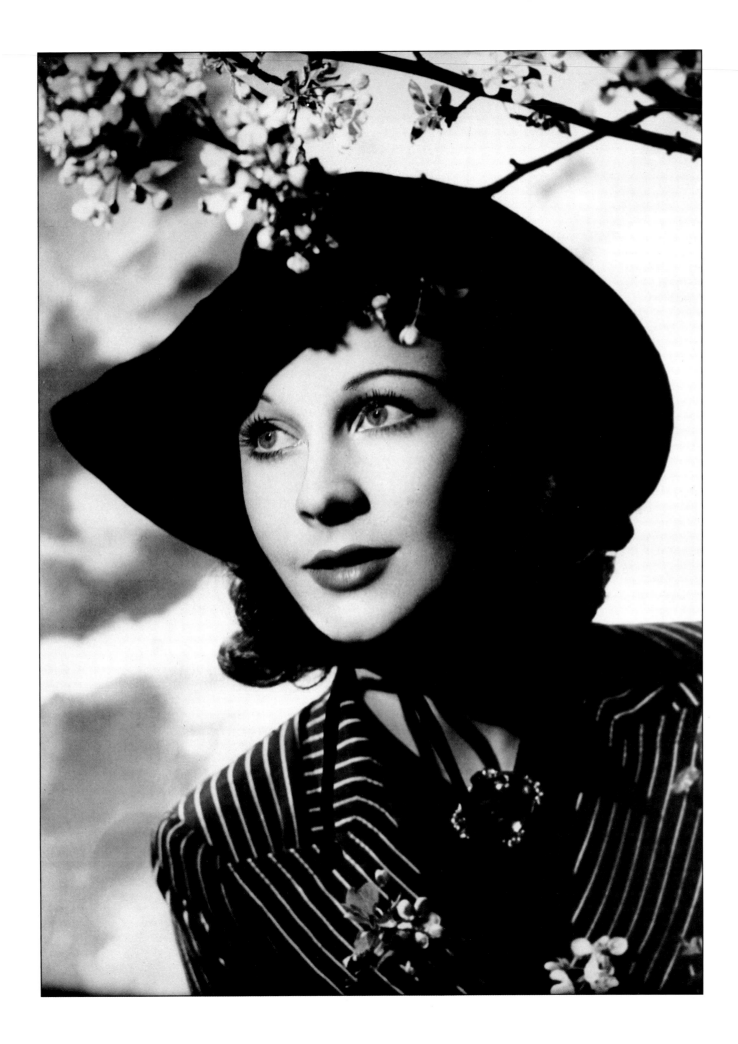

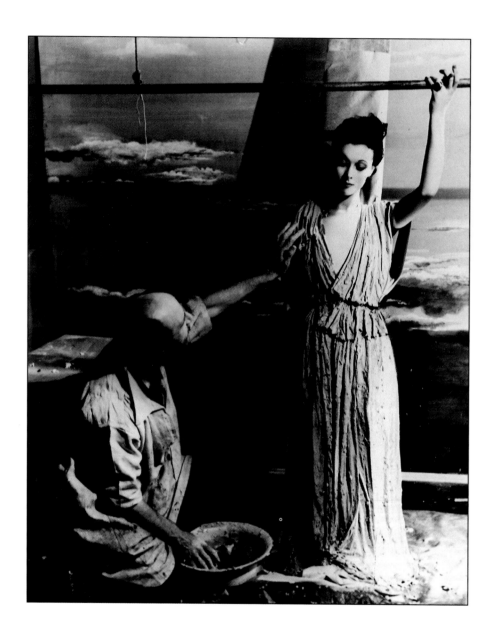

Making the Greek dress of cheap flannelette
and plaster of Paris for the picture opposite
(*see also page 21*). This shot was taken by
John Vickers, my assistant at the time.

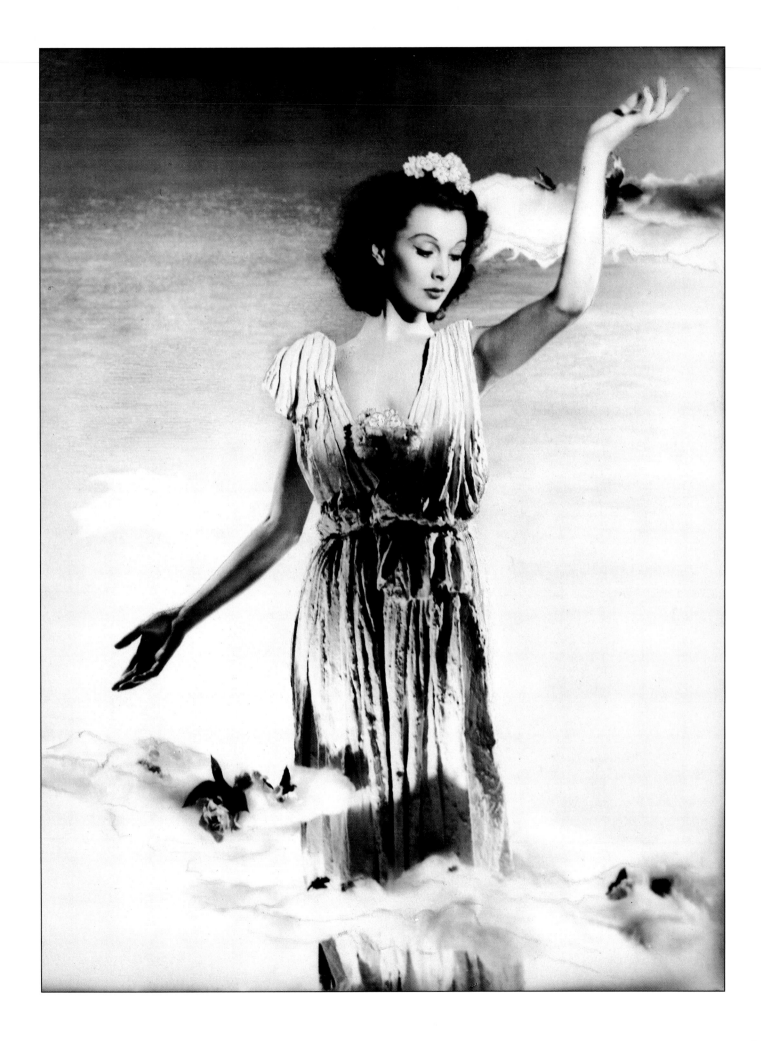

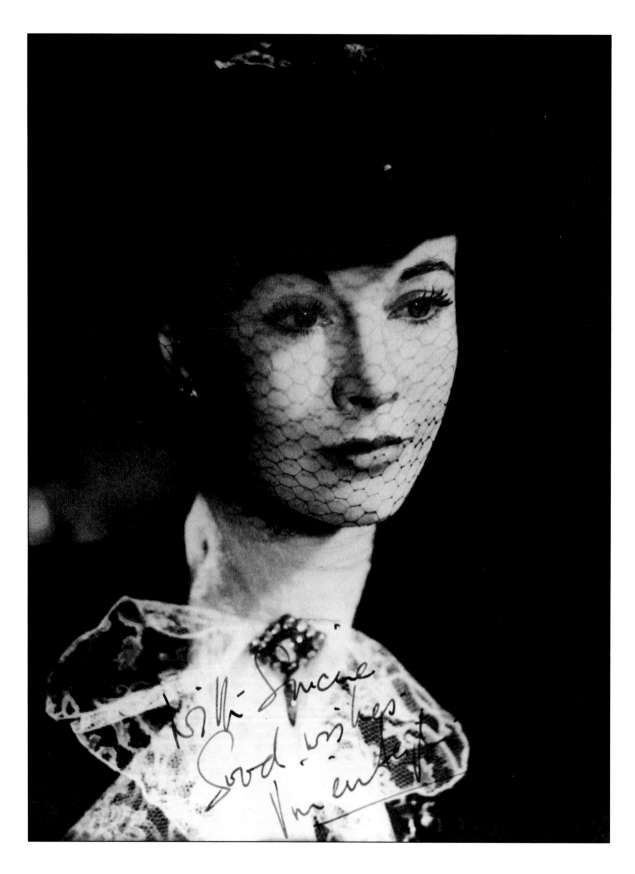

Vivien as Jennifer Dubedat in Shaw's *The Doctor's Dilemma*, taken in March 1942. The picture opposite is said to be Laurence Olivier's favourite photograph of her.

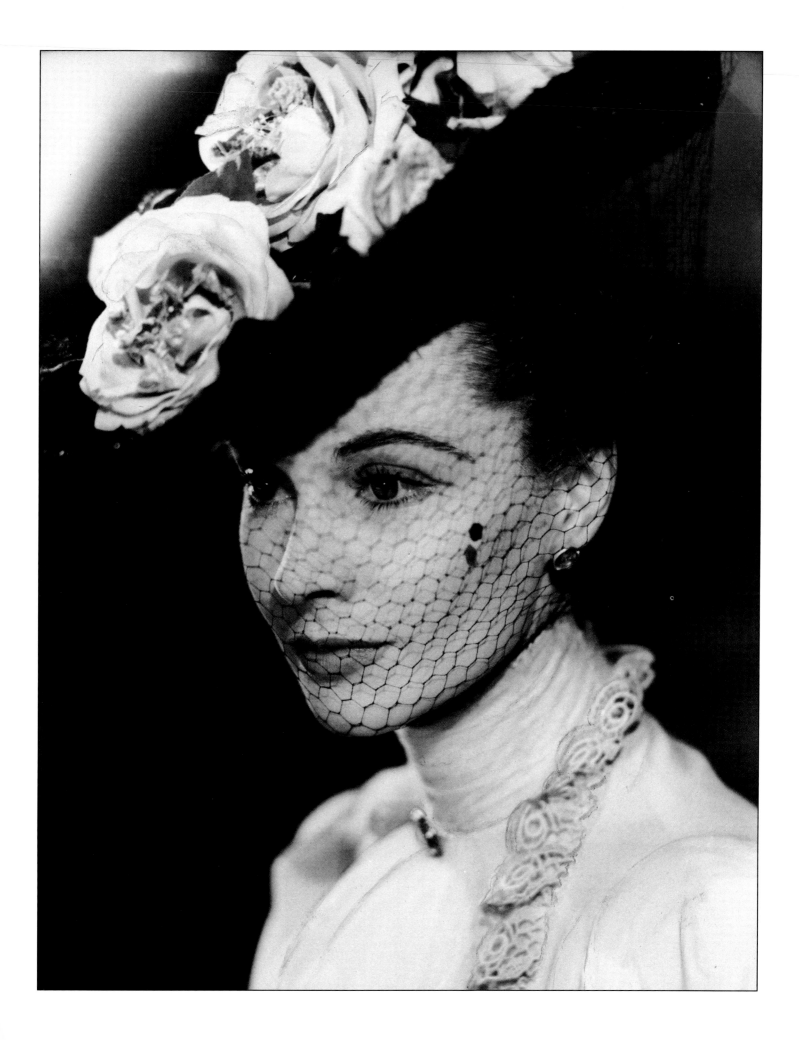

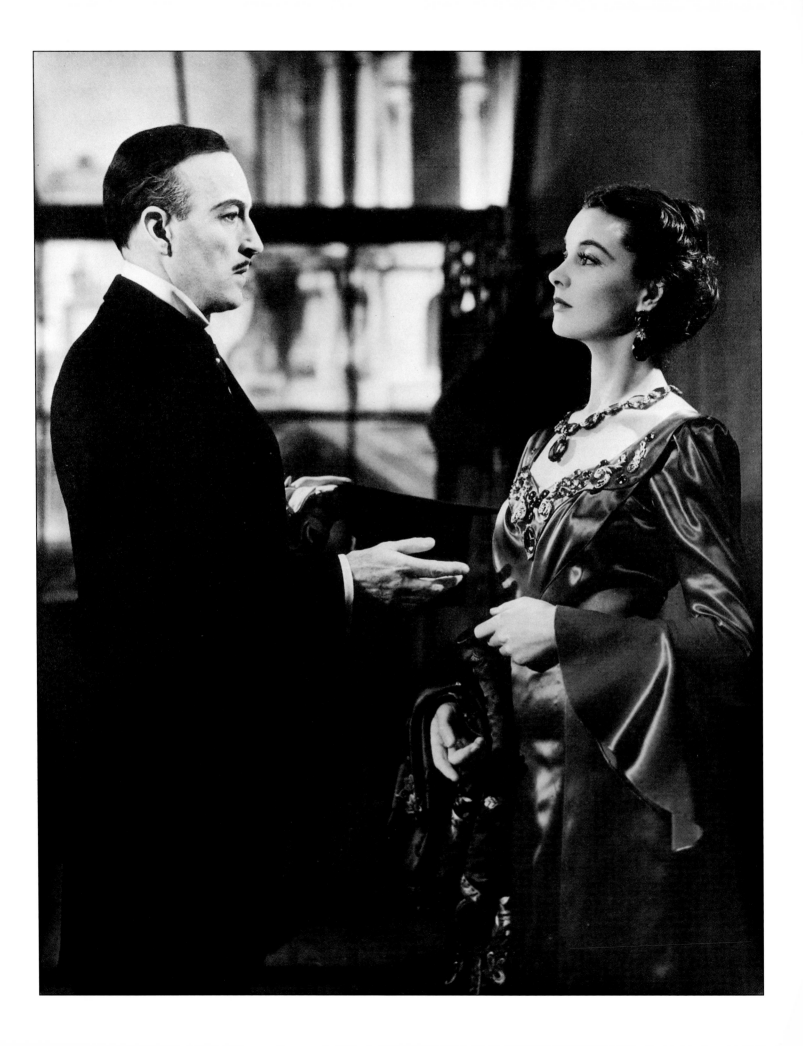

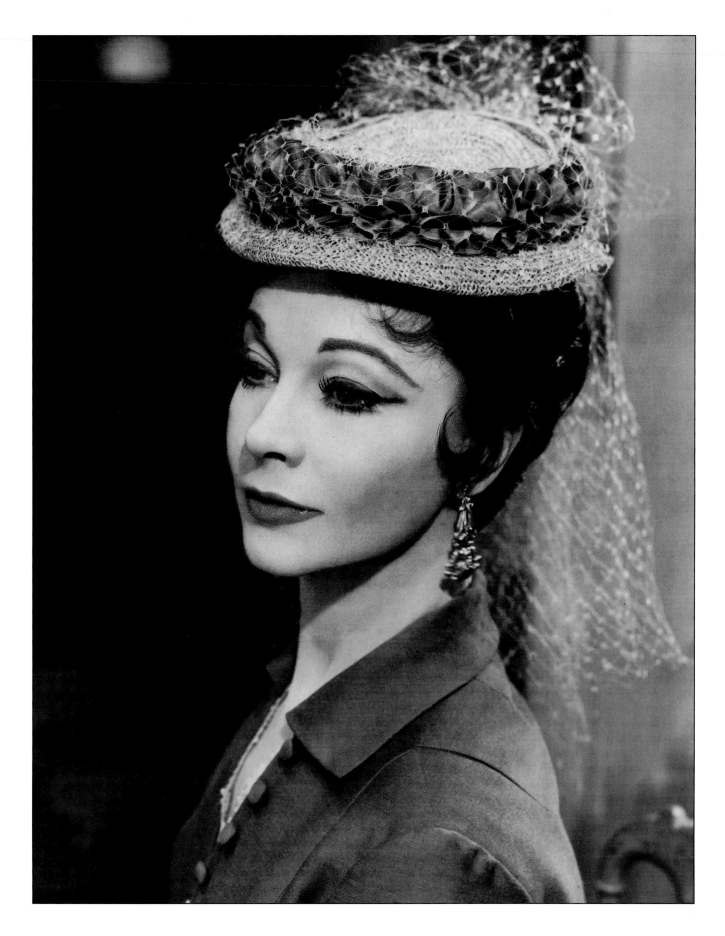

(*opposite*) As Jennifer Dubedat again, with
Austin Trevor.
(*above*) A single portrait from a later play,
Duel of Angels, performed in 1958.

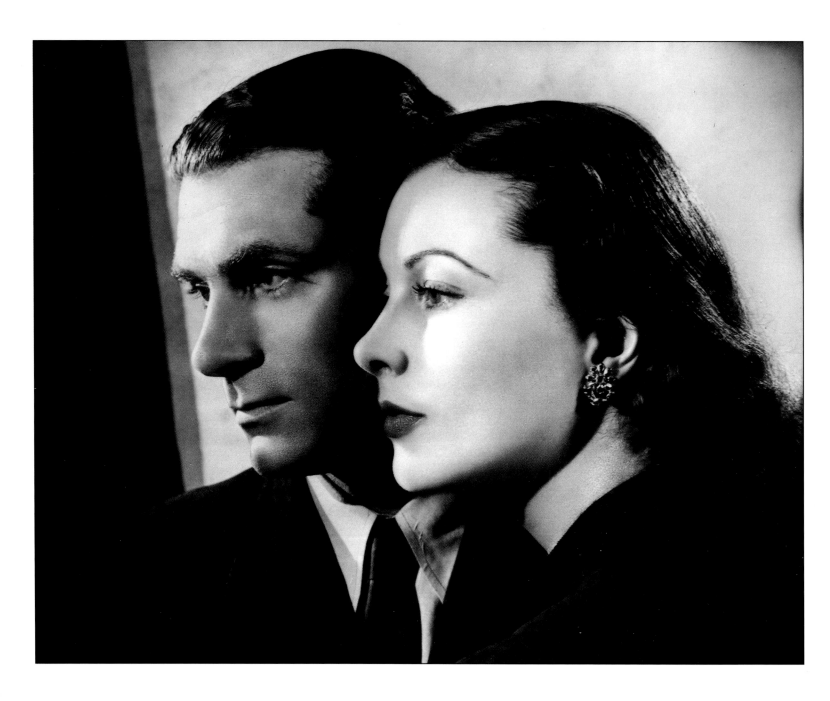

Two pictures from the only occasion when
Laurence Olivier and Vivien Leigh visited
my studio together on 13 November 1948.
Two very beautiful people – how often does
a photographer have such luck!

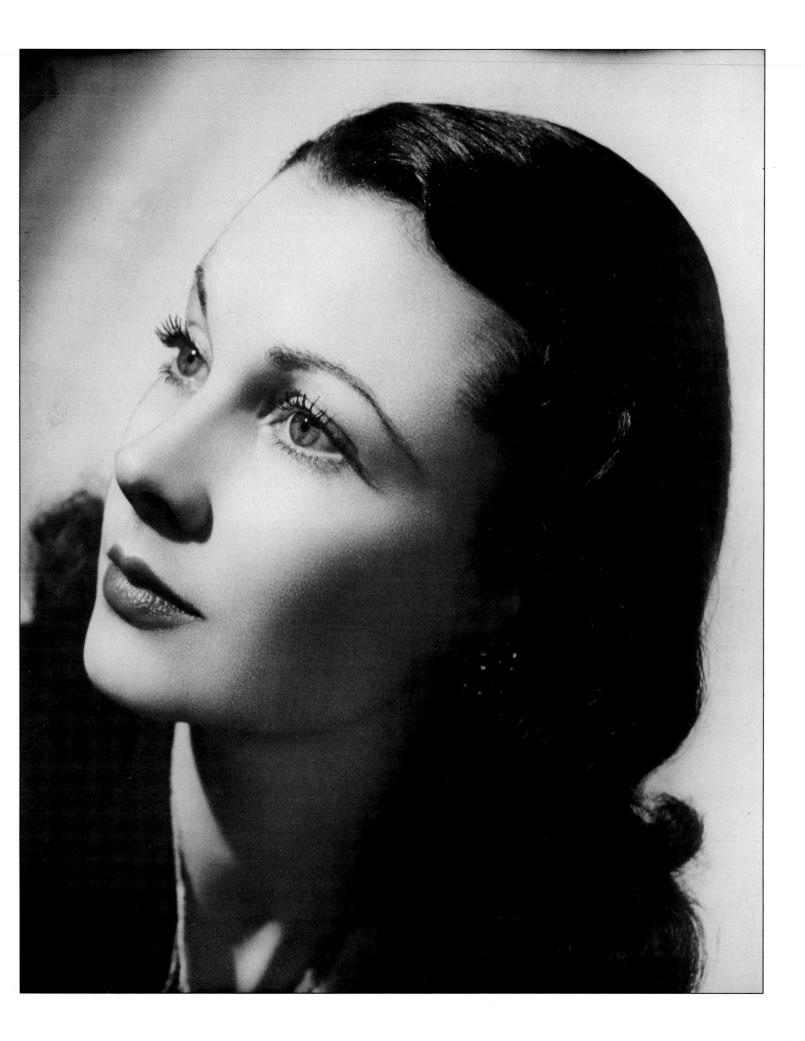

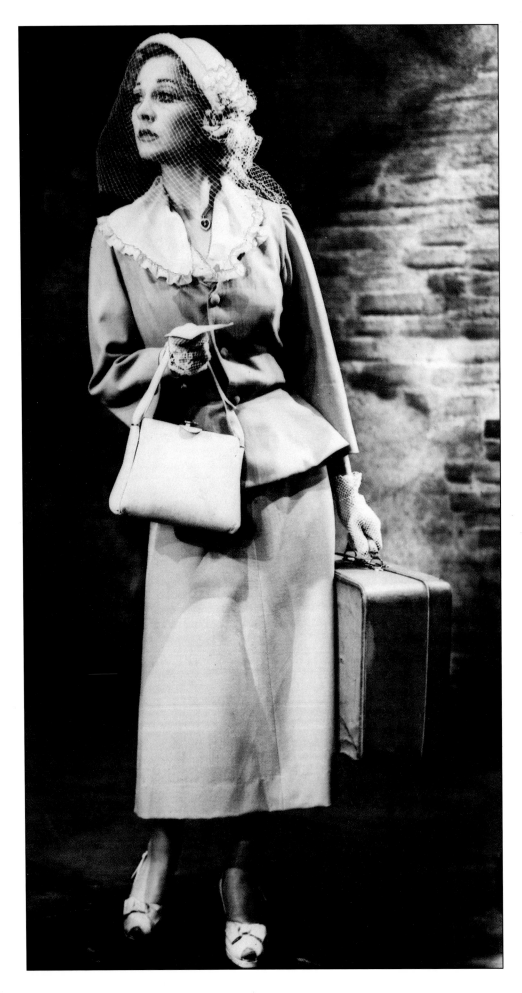

Vivien's first entrance as Blanche Dubois in Tennessee Williams's *A Streetcar Named Desire* (October 1949). In this shot Blanche, at the end of her tether, arrives at her sister's house.

(*right*) Vivien had her dark hair dyed blonde for this part. She could not wear a wig, as she would normally have done, because of the violence of the action in some scenes.

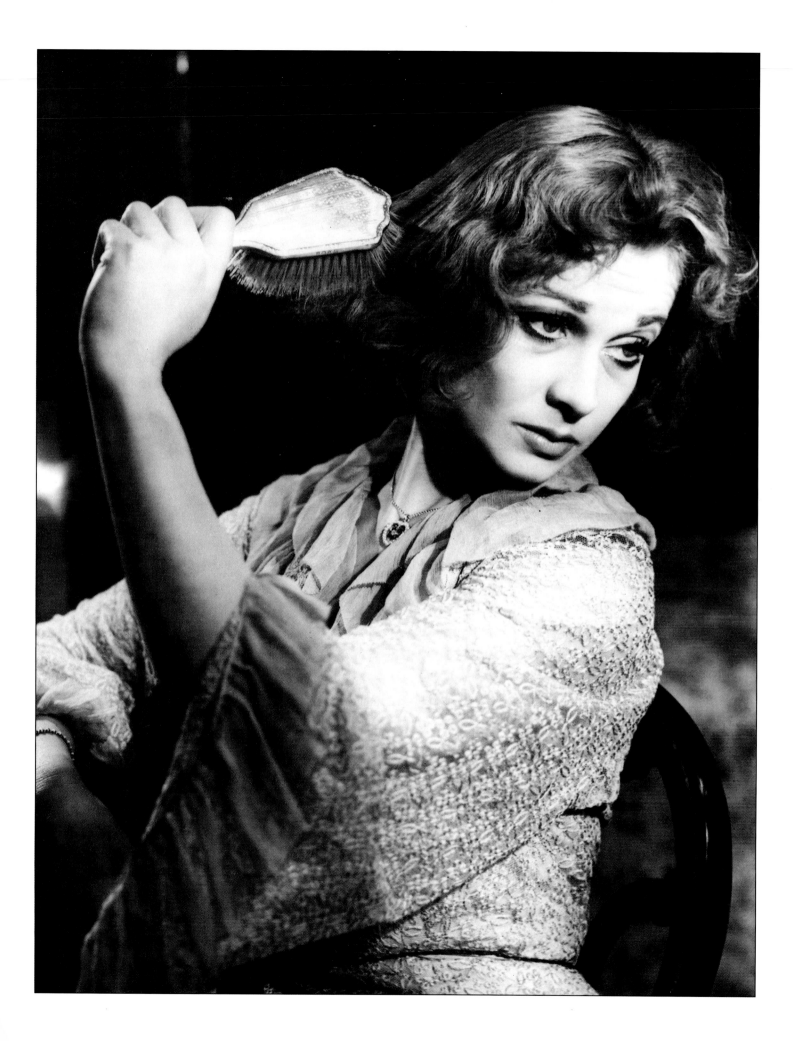

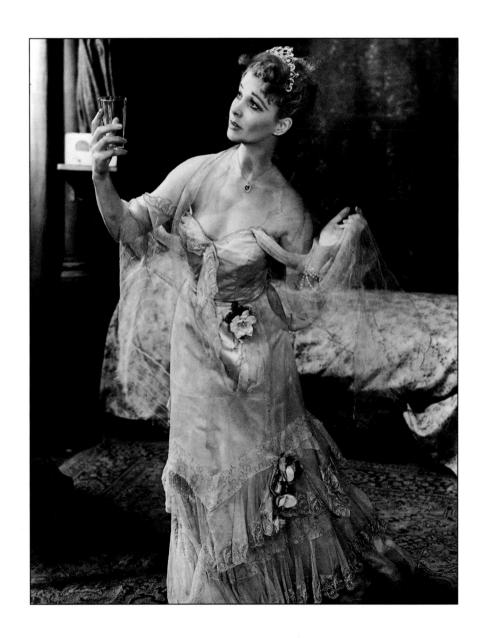

(*above*) Blanche in her finery. (*opposite*) The intensity of Vivien's portrayal, both on the stage and in the later film version, is sometimes blamed for her later ill-health.

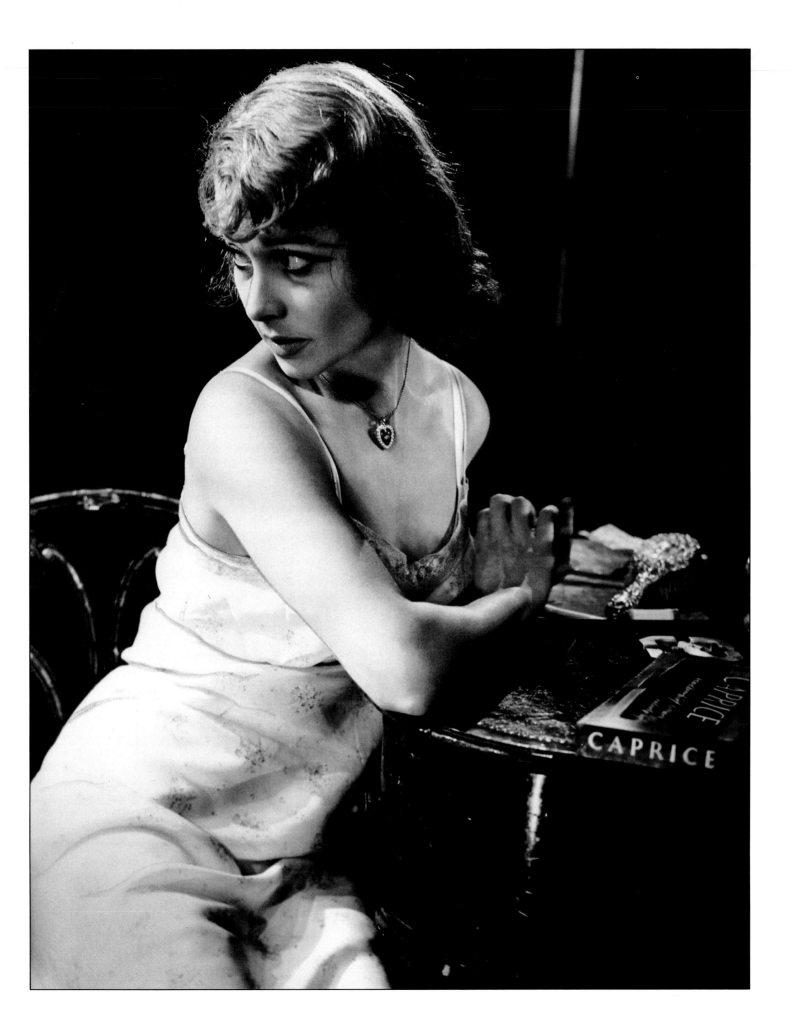

Vivien with Bonar Colleano who played
Stanley Kowalski in the stage version of
A Streetcar Named Desire.

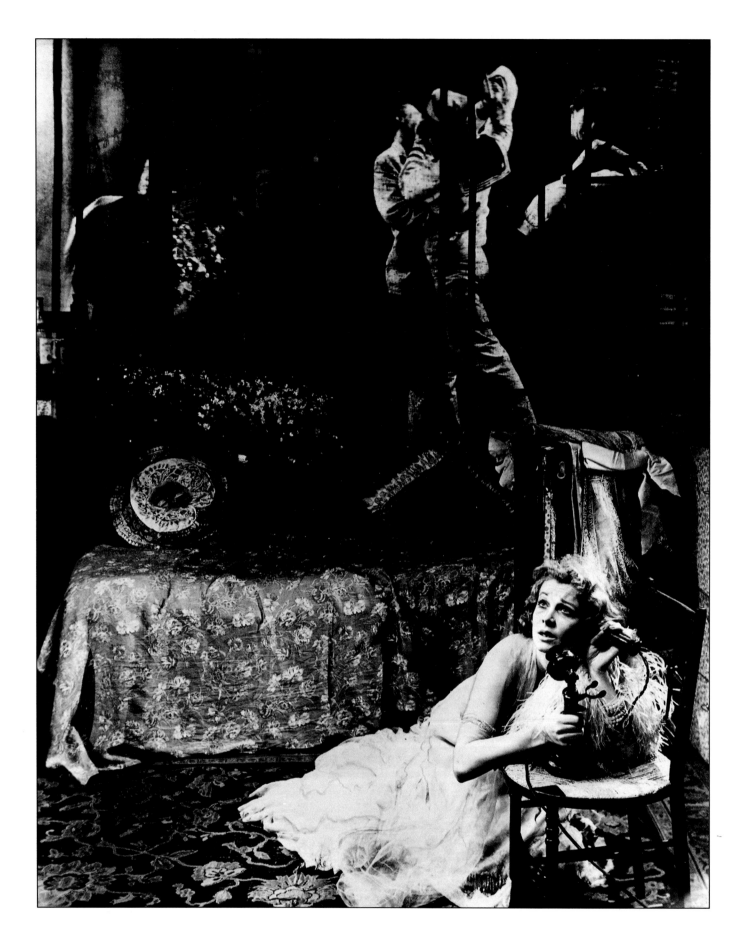

The mad scene in *A Streetcar Named Desire*
was one of the moments which made the
stage version so much superior to the film.

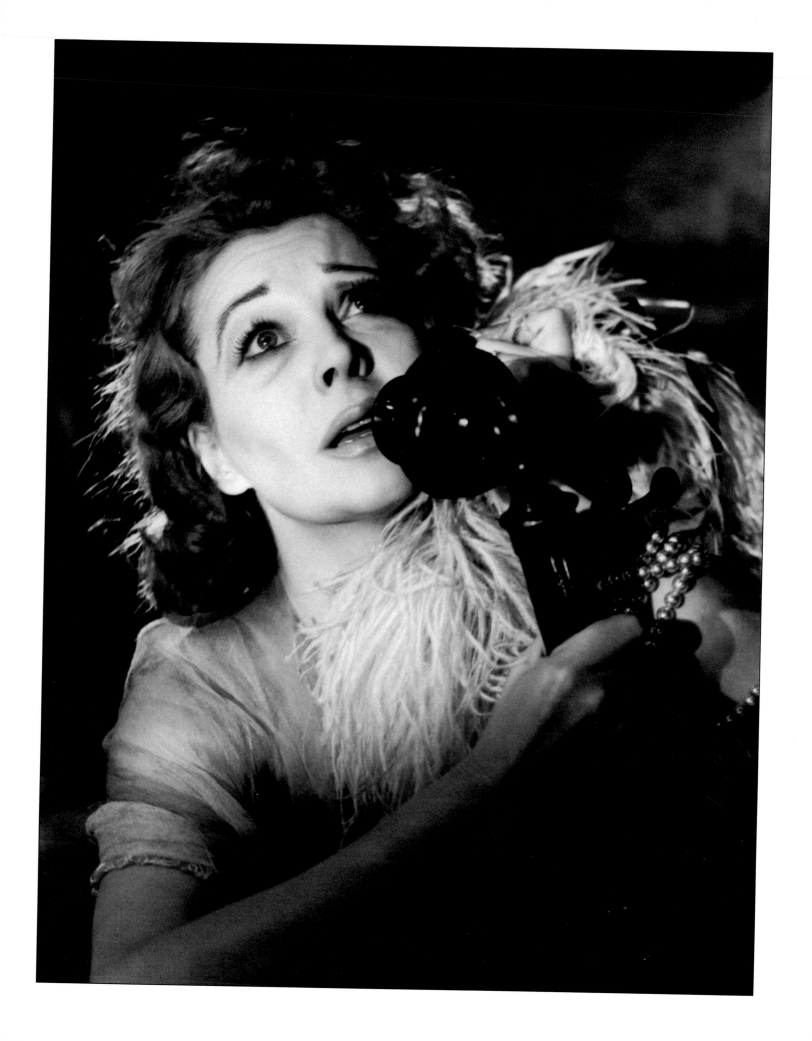

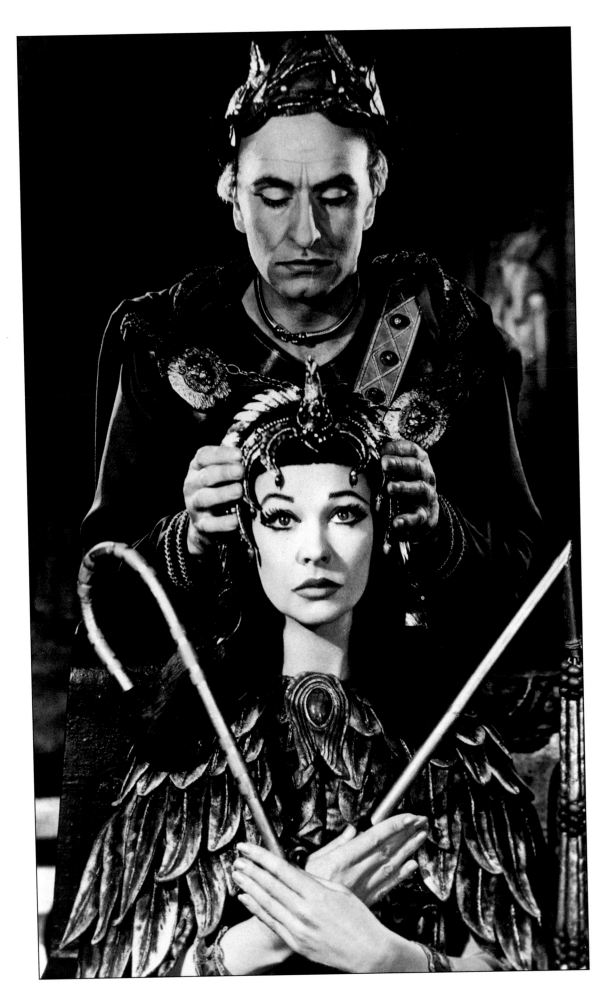

Vivien with Laurence Olivier in *Caesar and Cleopatra*, here playing the sixteen-year-old Cleopatra of Shaw's play. Photographed in Manchester prior to production at the St. James's Theatre in May 1951.
This was the theatre Vivien loved and tried to save by interrupting a debate in the House of Lords.

(*overleaf*) Two close-ups of Vivien from the same play.

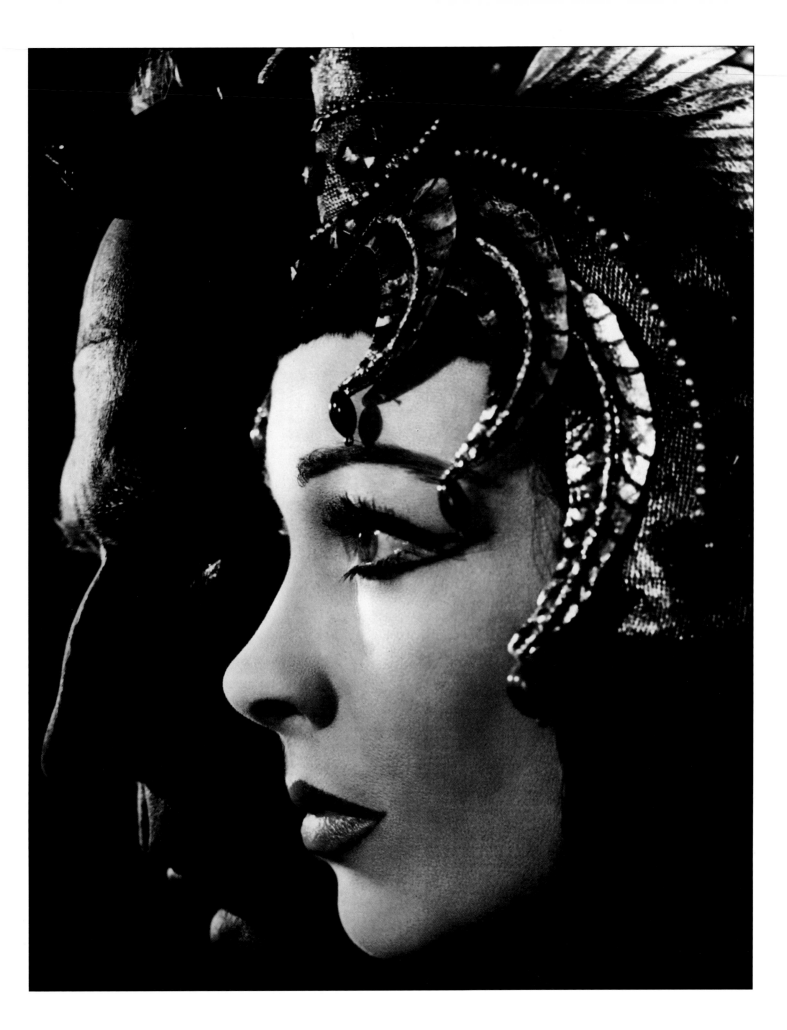

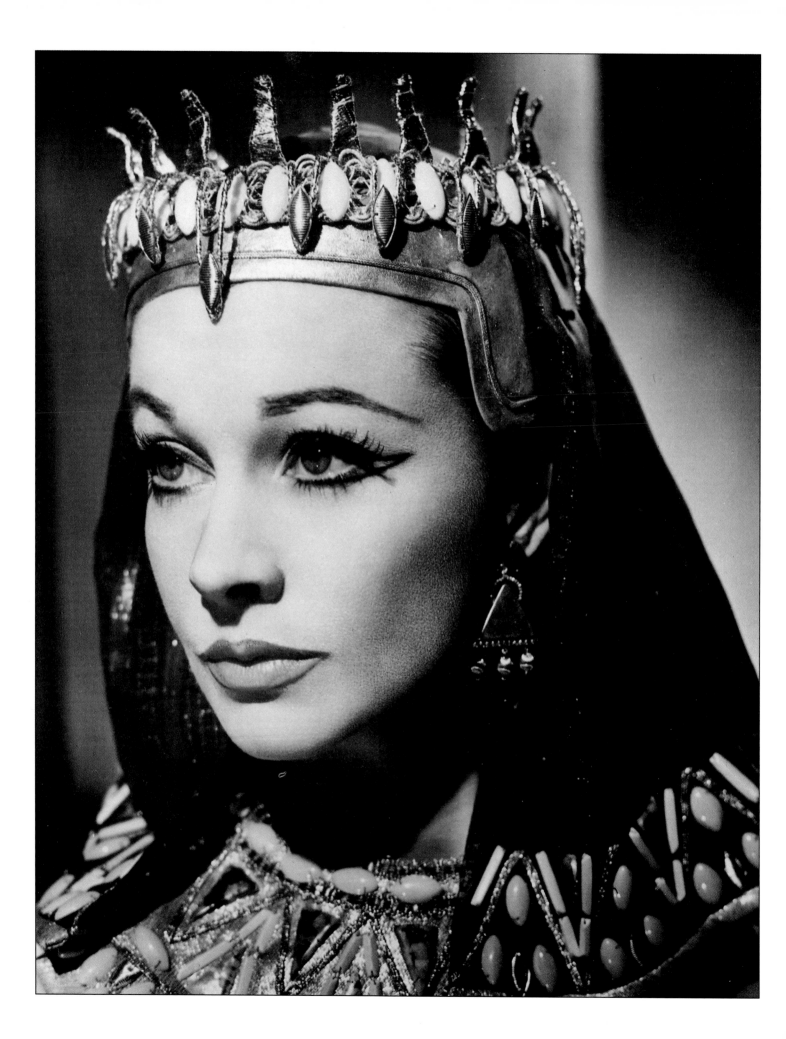

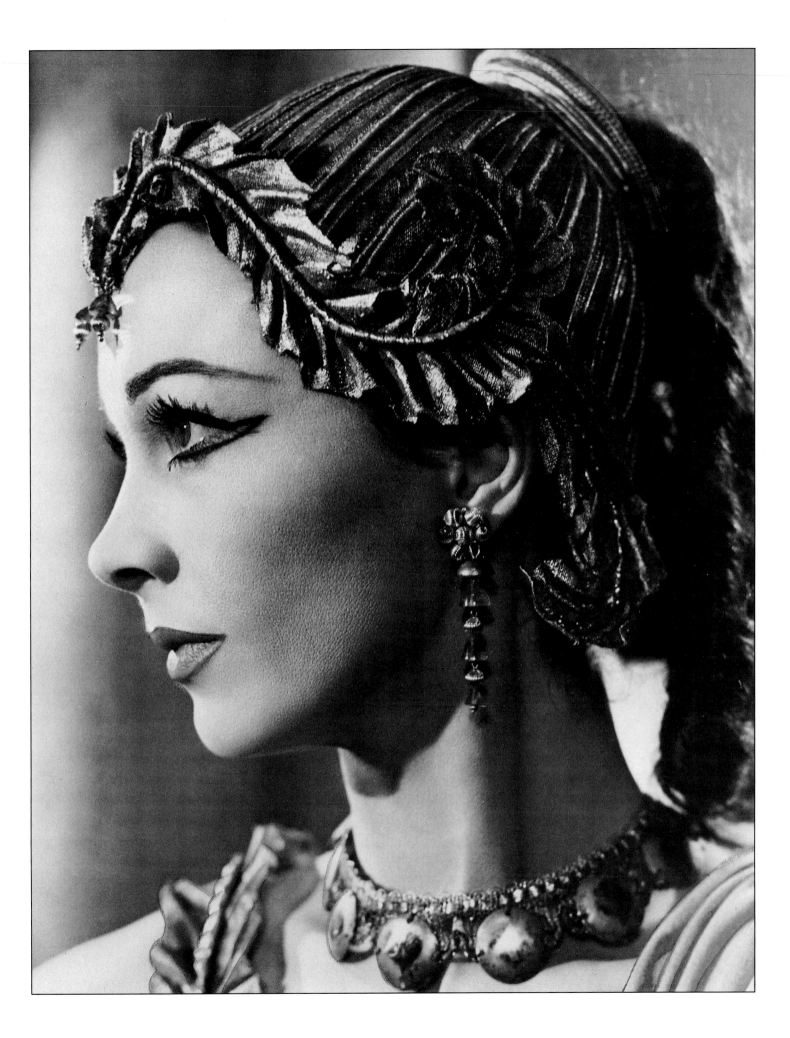

A group shot from *Caesar and Cleopatra*,
including the Oliviers and Robert Helpman
as Apollodorus.
Ziegfield Theatre, December 1951.

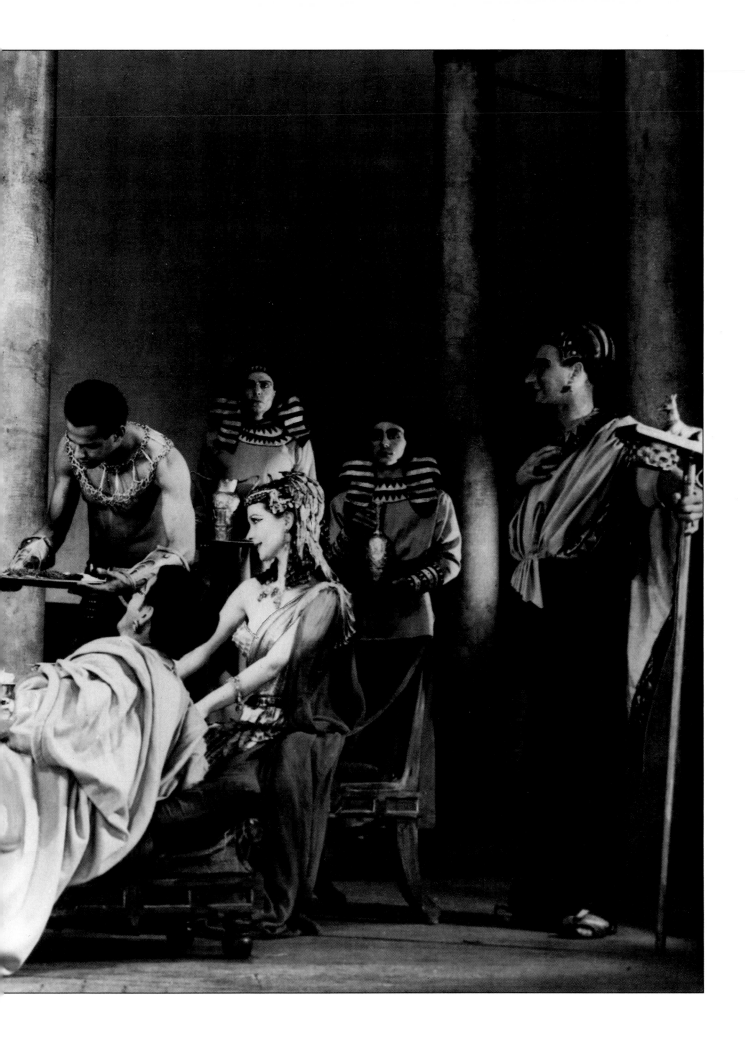

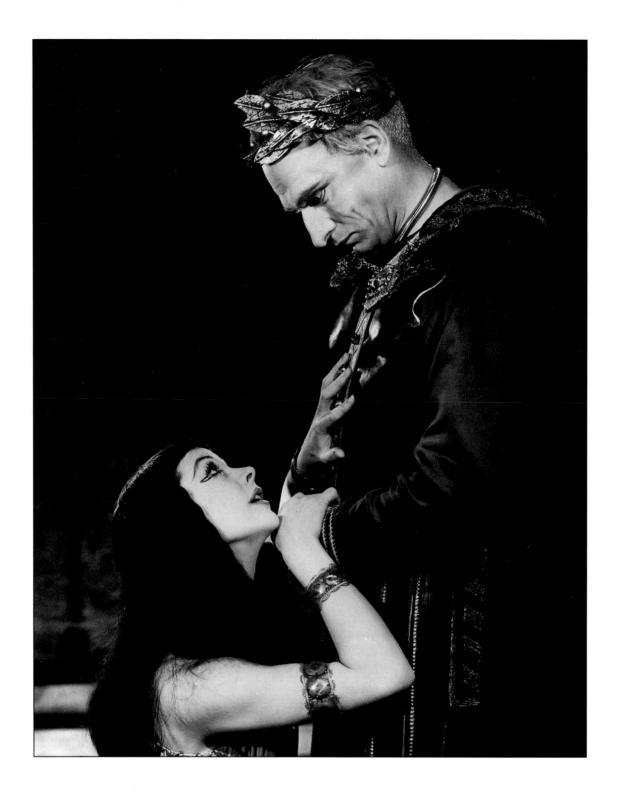

These two photographs of the Oliviers, from
Caesar and Cleopatra (*above*) and Shakespeare's
Antony and Cleopatra (*right*), which were given
together in repertory, illustrate Vivien's
transformation from the sixteen-year-old
girl to the mature thirty-four-year-old
queen. Equally extraordinary was Laurence
Olivier's transformation from the ageing
Caesar into the beautiful, romantic Antony.

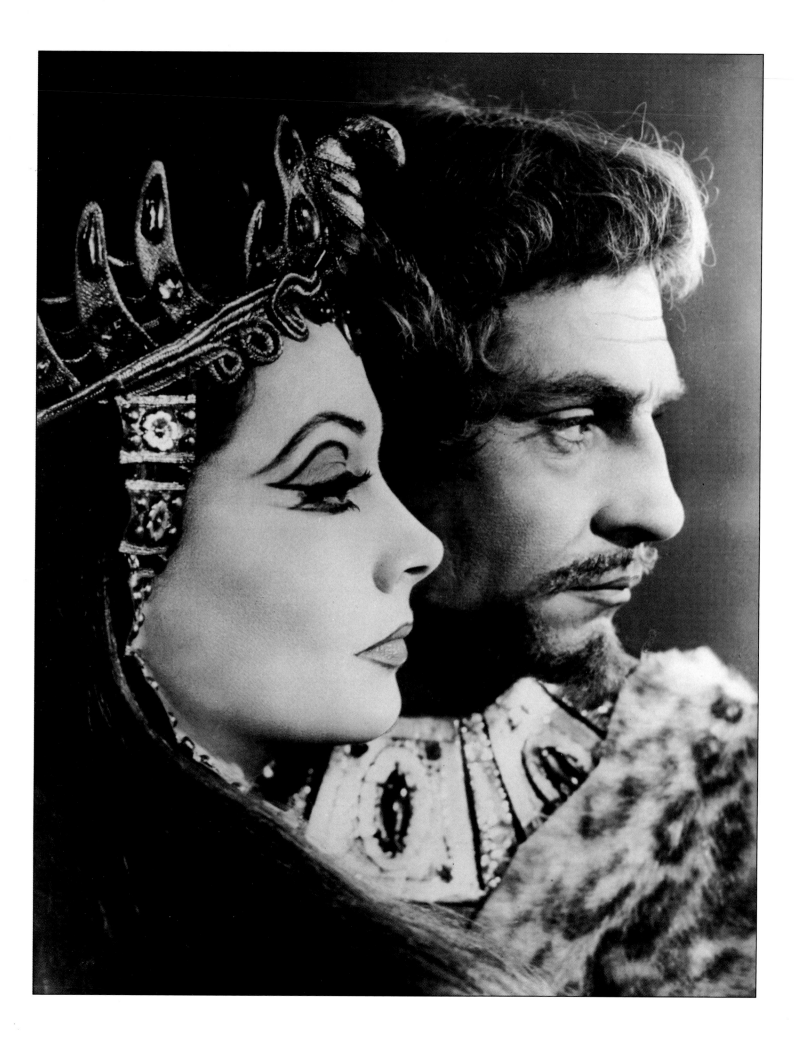

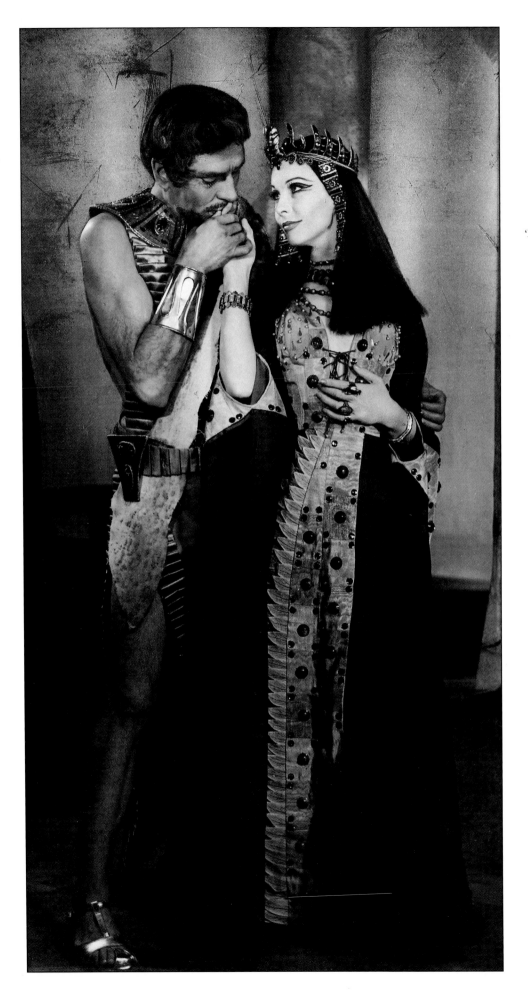

'If it be love indeed, tell me how much.'

Act I, Scene I, *Antony and Cleopatra*.

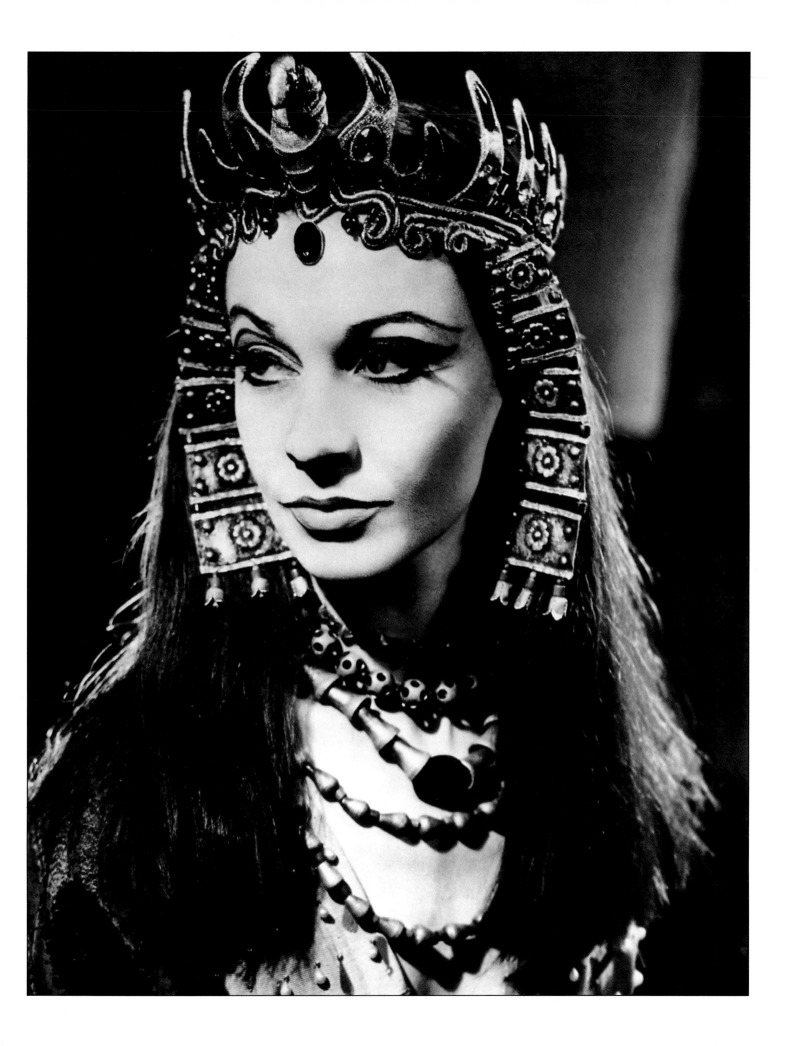

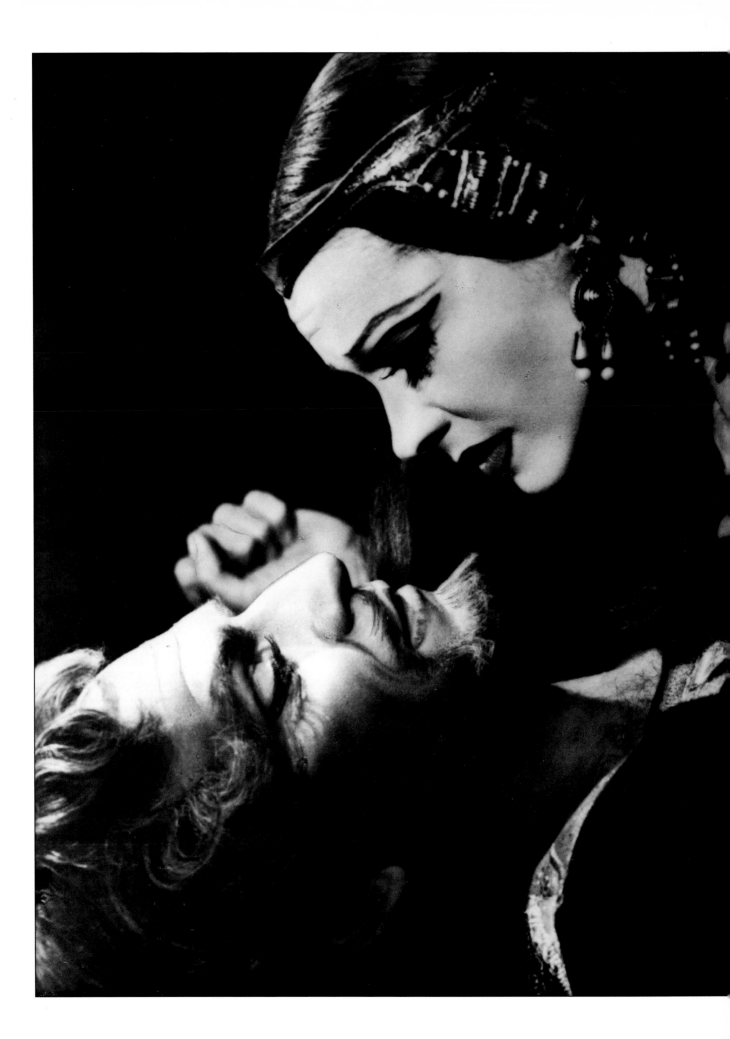

The death scene on the monument in *Antony
and Cleopatra*.

'I am dying, Egypt, dying.'
Act IV. Scene XIII.

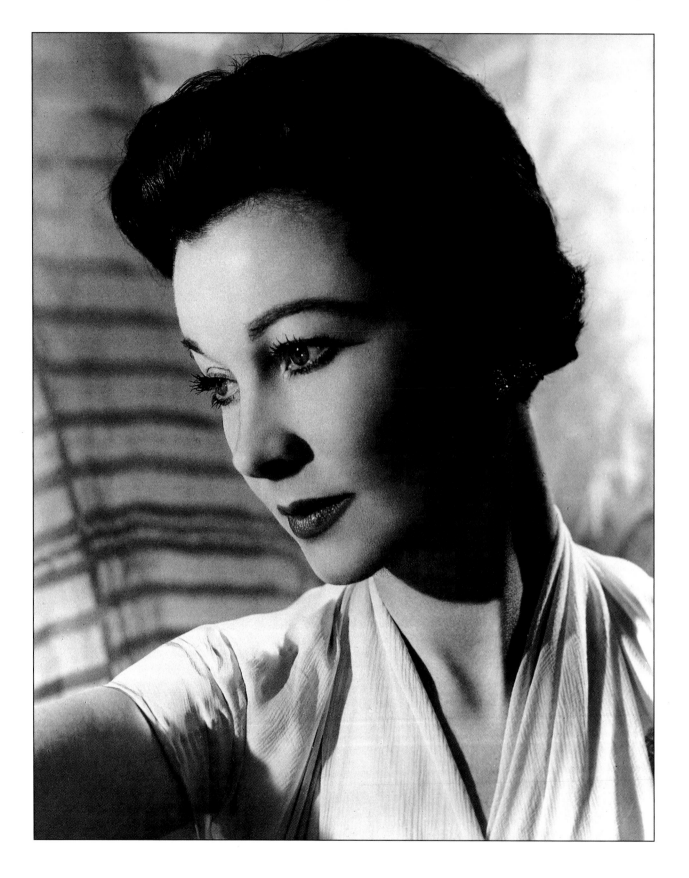

Taken in my London studio, 1951.

(*opposite*) The double-exposure portrait,
taken in 1952, which hangs in the National
Portrait Gallery, London.

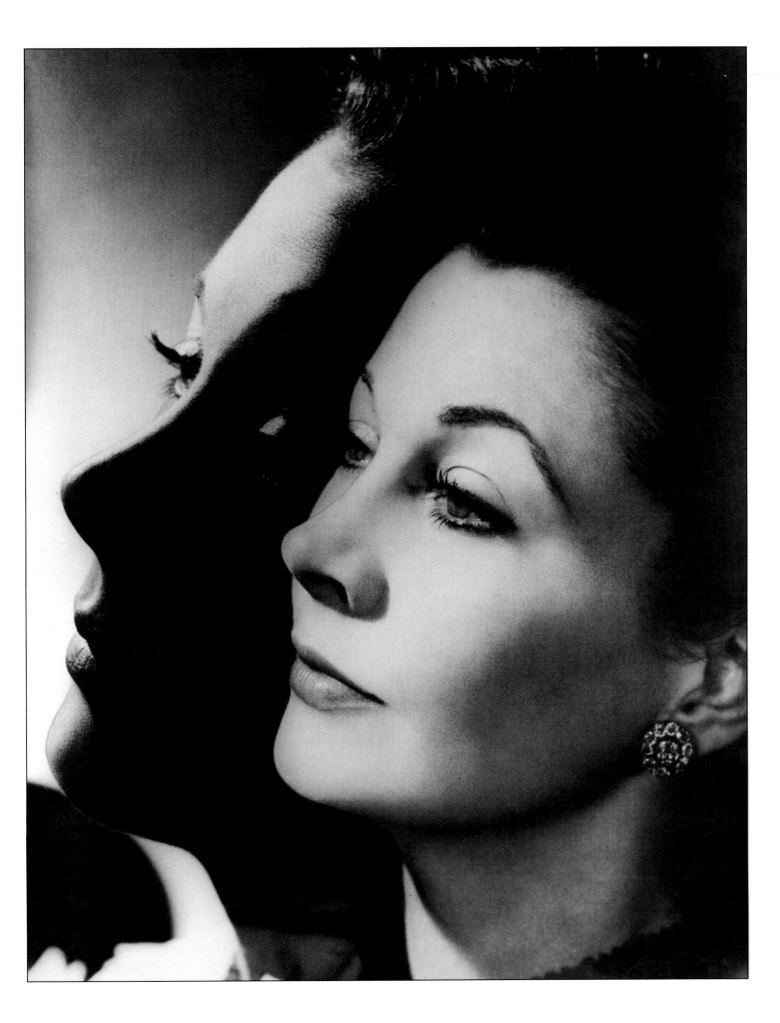

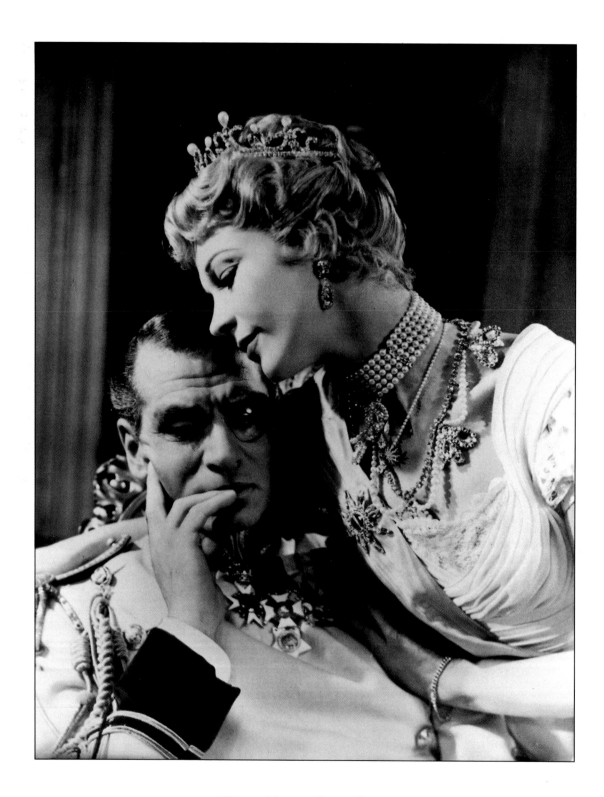

Vivien with Laurence Olivier in Terence
Rattigan's *The Sleeping Prince*, taken in the
Phoenix Theatre, London, in November
1953. Marilyn Monroe played the part in the
subsequent film version,
The Prince and the Showgirl.

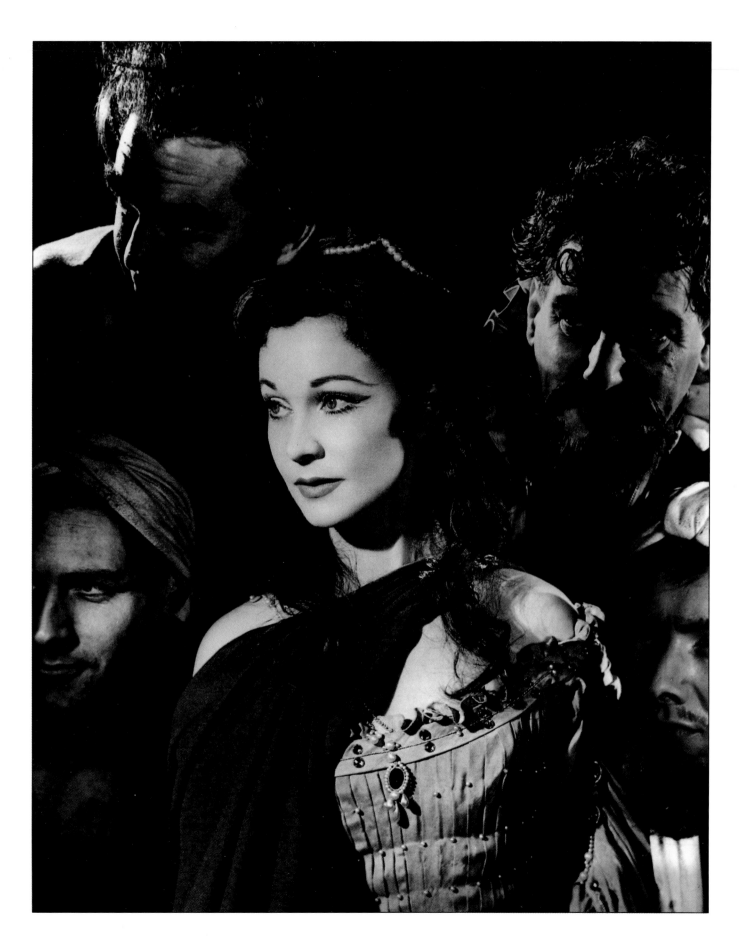

As Viola with the sailors in *Twelfth Night*.
Stratford, April 1955.
'What country, friends, is this?'
Act I, Scene II.

Also from *Twelfth Night*. Here Viola is
disguised as a boy, Cesario. In the picture
above, she ingratiates herself with the
Countess Olivia, played by Maxine Audley.

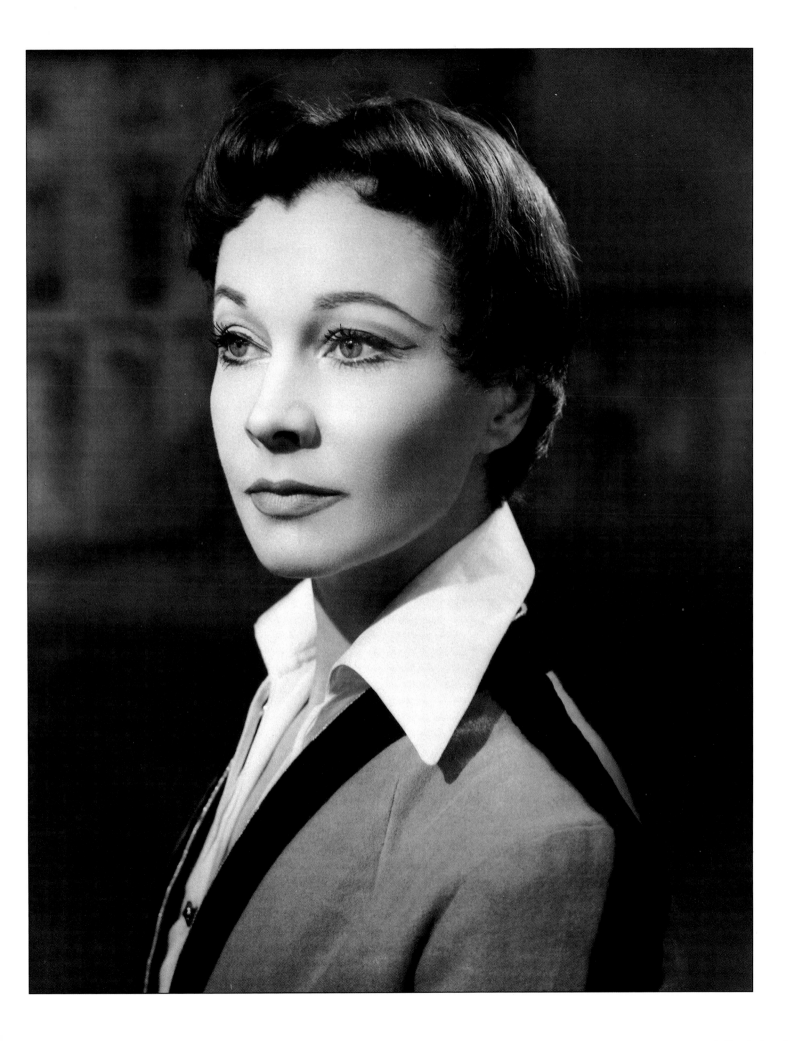

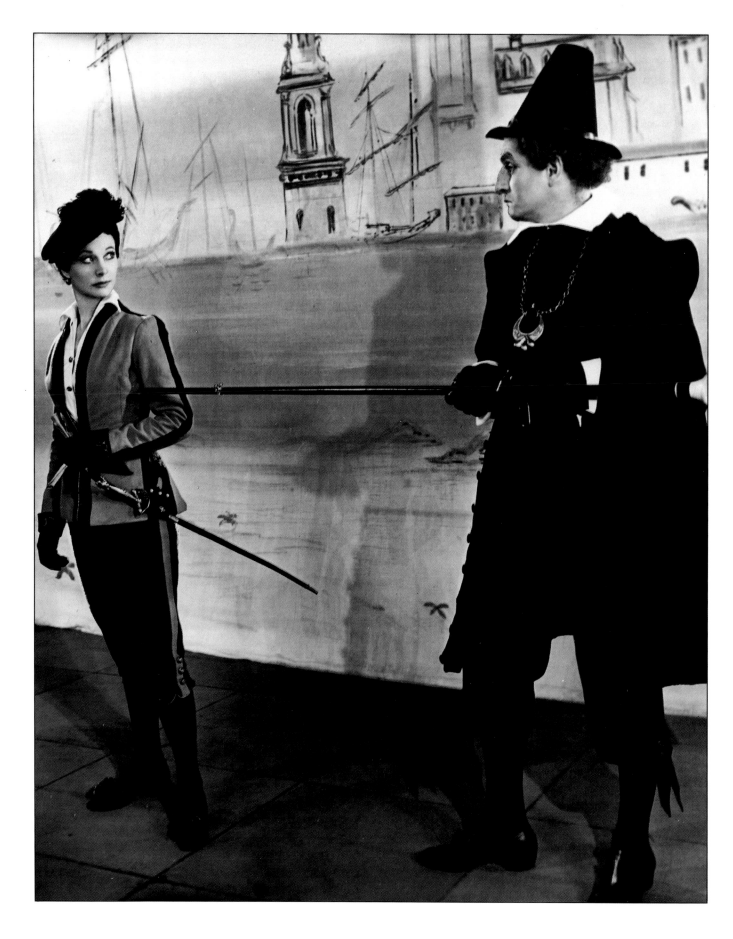

With Laurence Olivier as Malvolio.
'She returns this ring to you, Sir.'
Act I, Scene II.

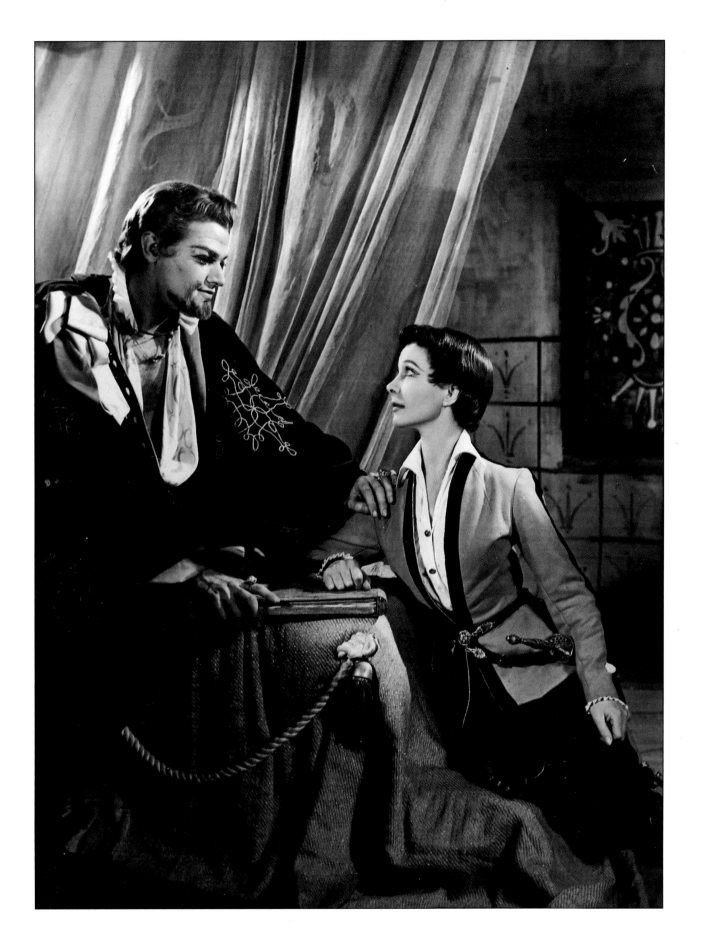

In the same production Keith Michell played
Duke Orsino, with whom 'Cesario' falls in
love.

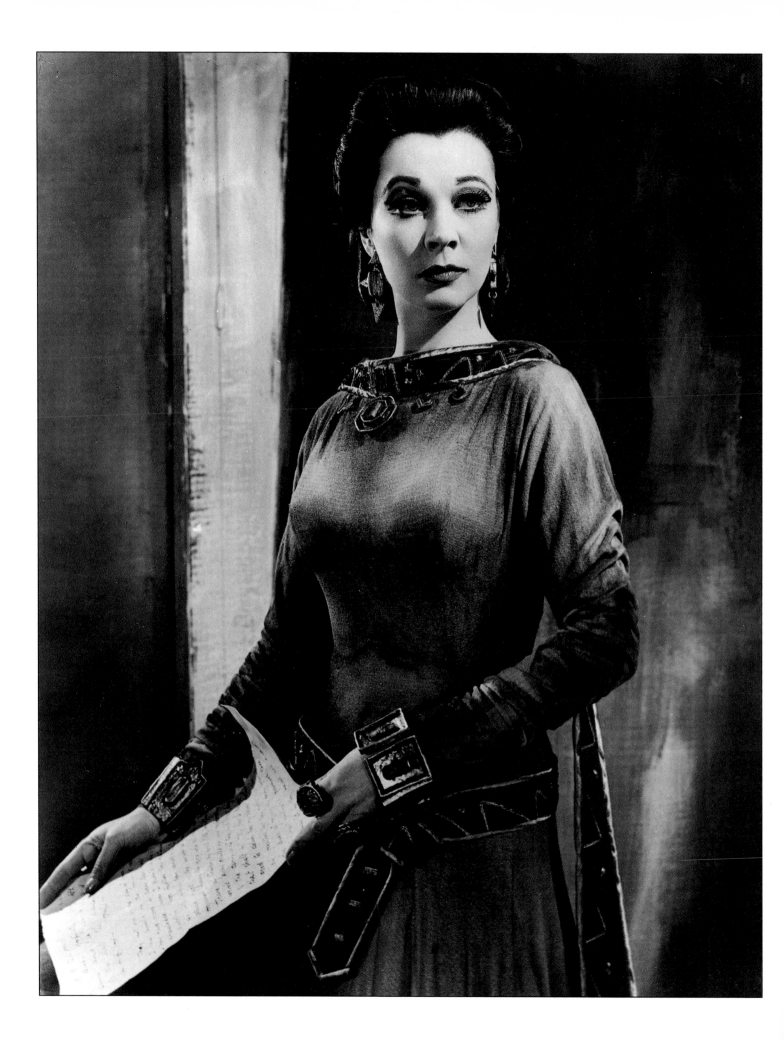

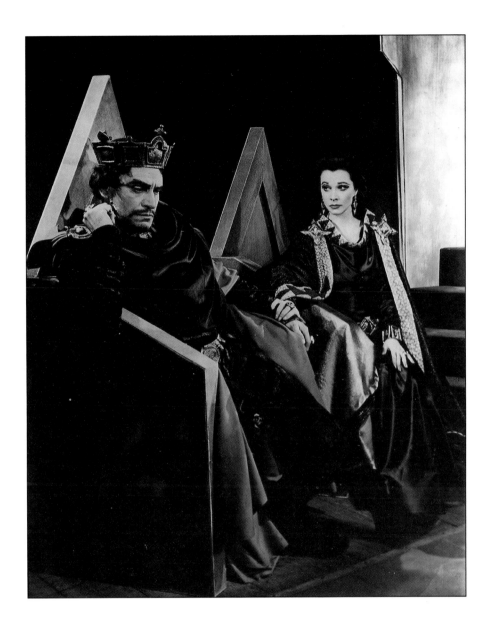

Vivien in the 1955 Stratford production of
Macbeth. In the letter scene (*left*) and (*above*)
with Laurence Olivier as Macbeth. Her
performance as Lady Macbeth has been
widely praised, notably by John Gielgud and
the critic Ivor Brown, who said of her;
'Red-haired, green-gowned, exquisite of
aspect, hard of grain . . . She looked the
perfect queen for this king. For once the
Macbeths, instead of appearing, as all too
often, to be a couple of "stars" who dislike
each other, were credible as man and wife.
Here is a woman who would have so
prevailed . . .'

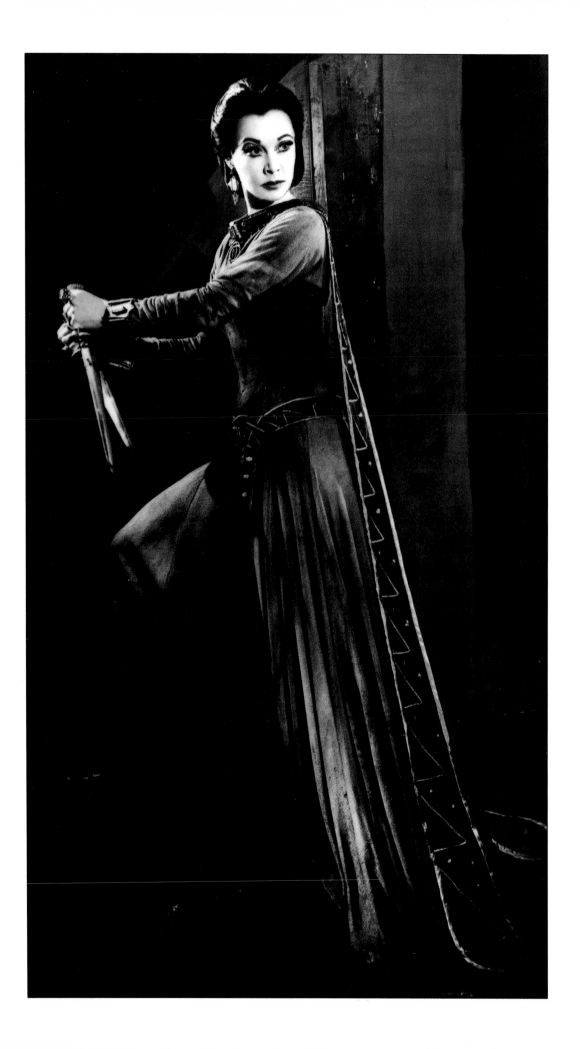

Vivien demonstrating the toughness and conviction which Ivor Brown commented on in her performance as Lady Macbeth.

'...come to my woman's breasts,
and take my milk for gall,
you murdering ministers,'
Act I, Scene V.

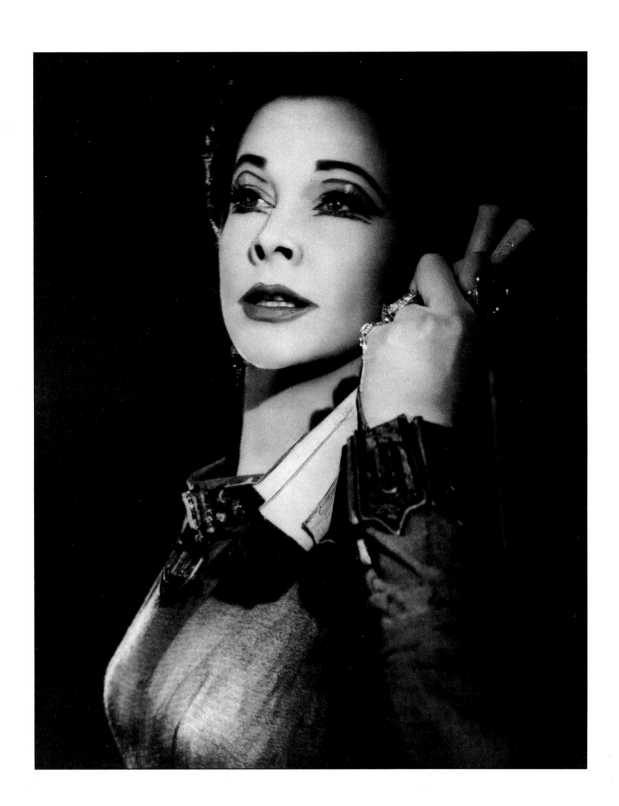

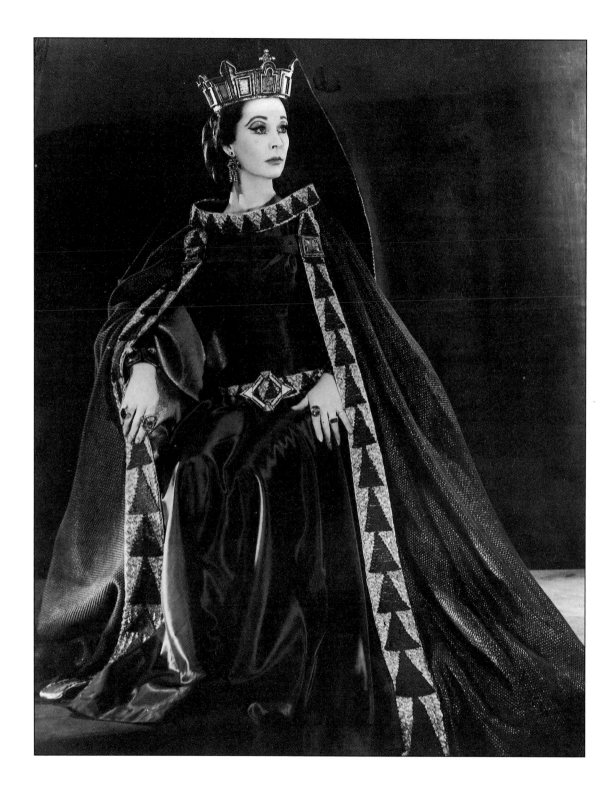

Lady Macbeth (*above*) regal of aspect, and
(*right*) a close-up shot from later in the play,
revealing the beginnings of doubt.

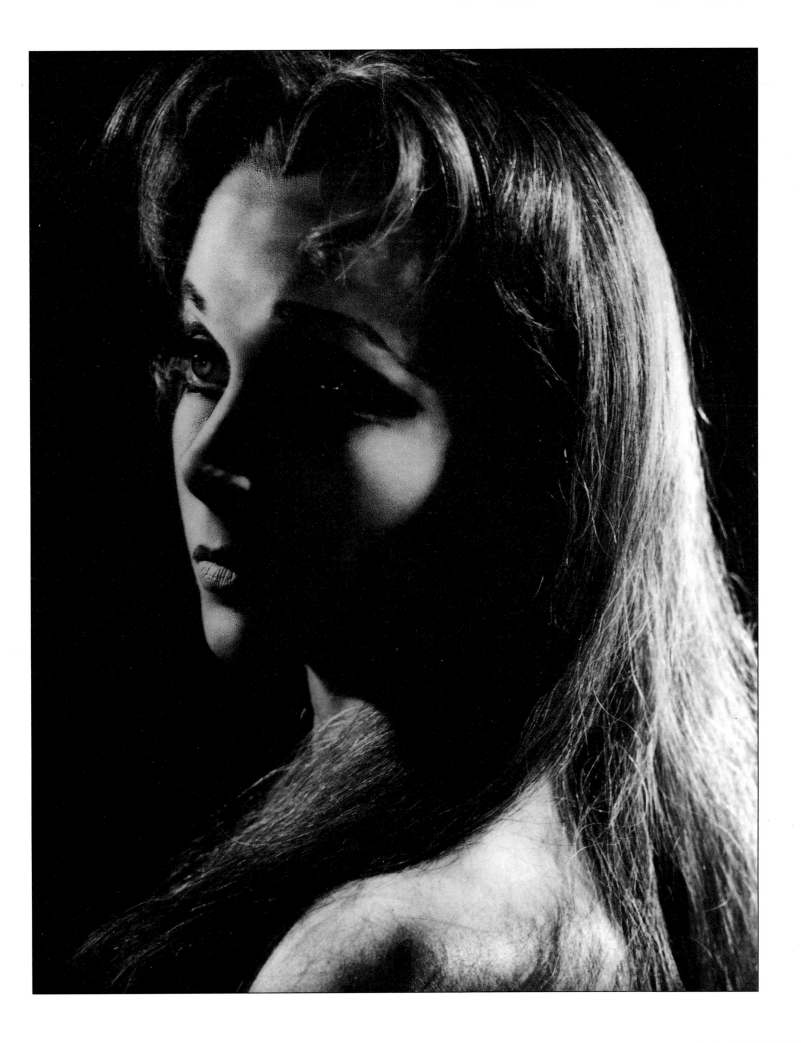

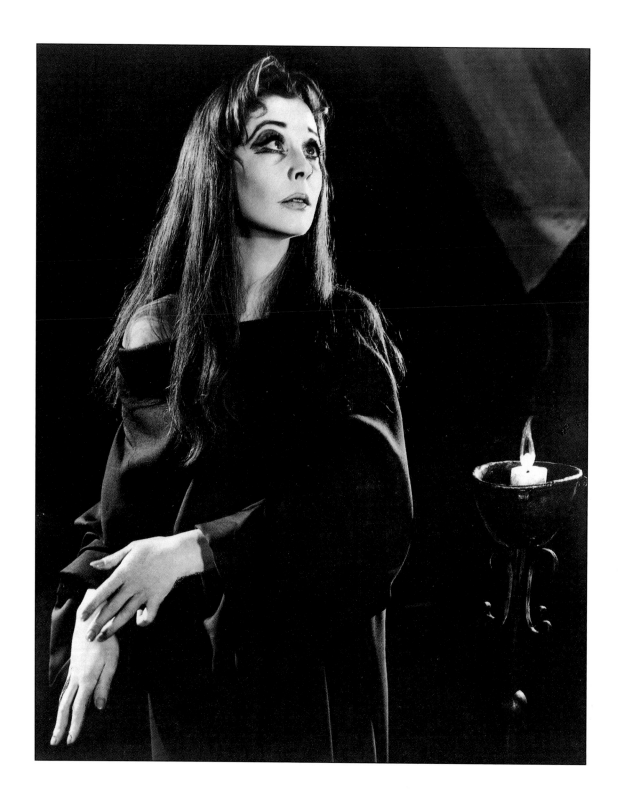

Two pictures from the famous sleep-walking
scene in *Macbeth*. Vivien played the whole
scene with her eyes crossed to simulate the
unfocused look of people in that state.

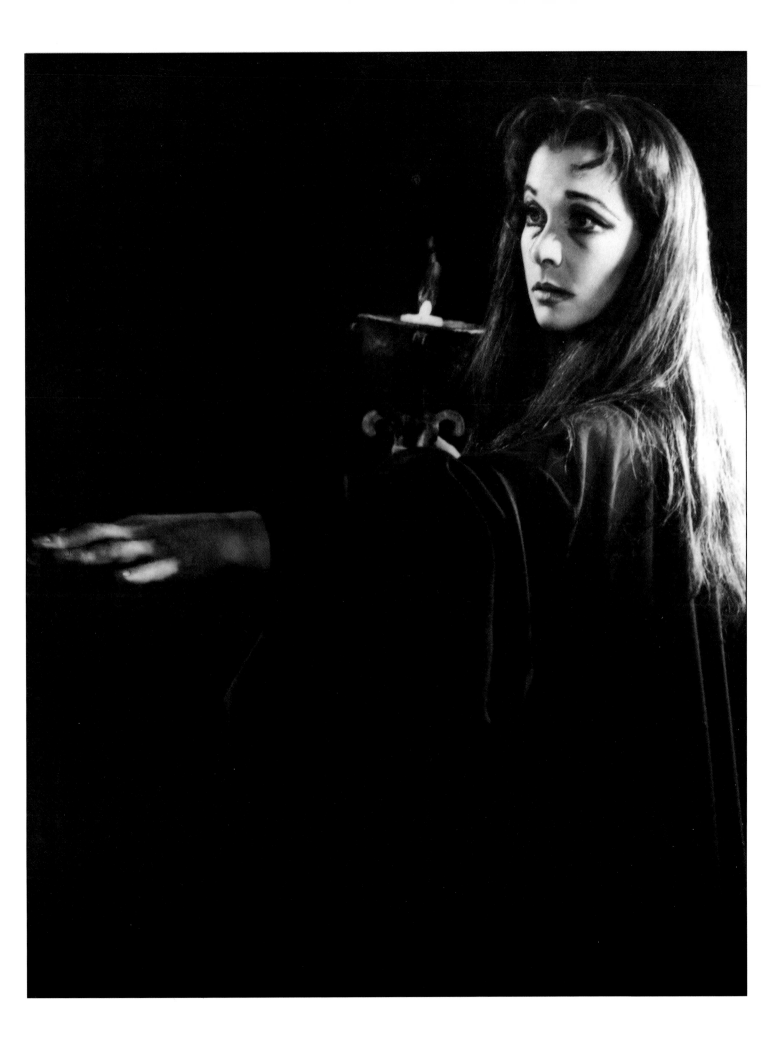

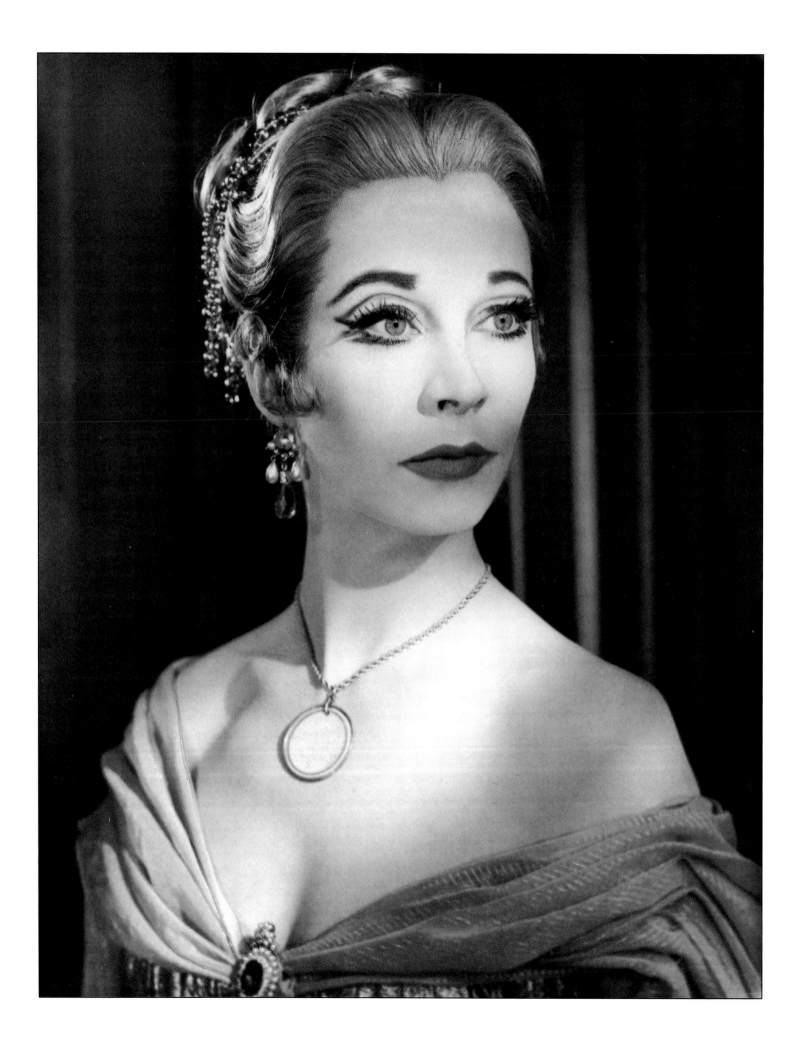

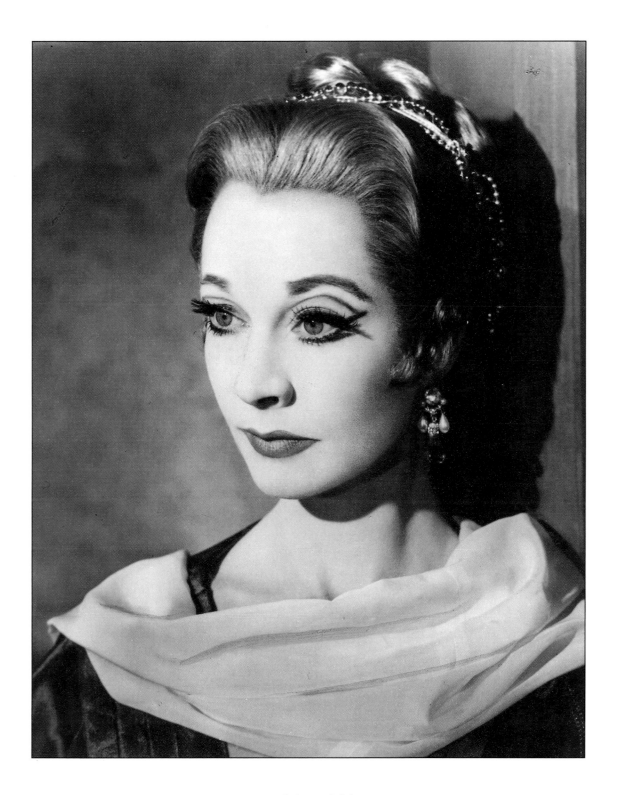

On stage with the Royal Shakespeare
Company again, as Lavinia in the 1955
Stratford production of *Titus Andronicus*.
Here she appears as the beautiful young
princess in the first act.

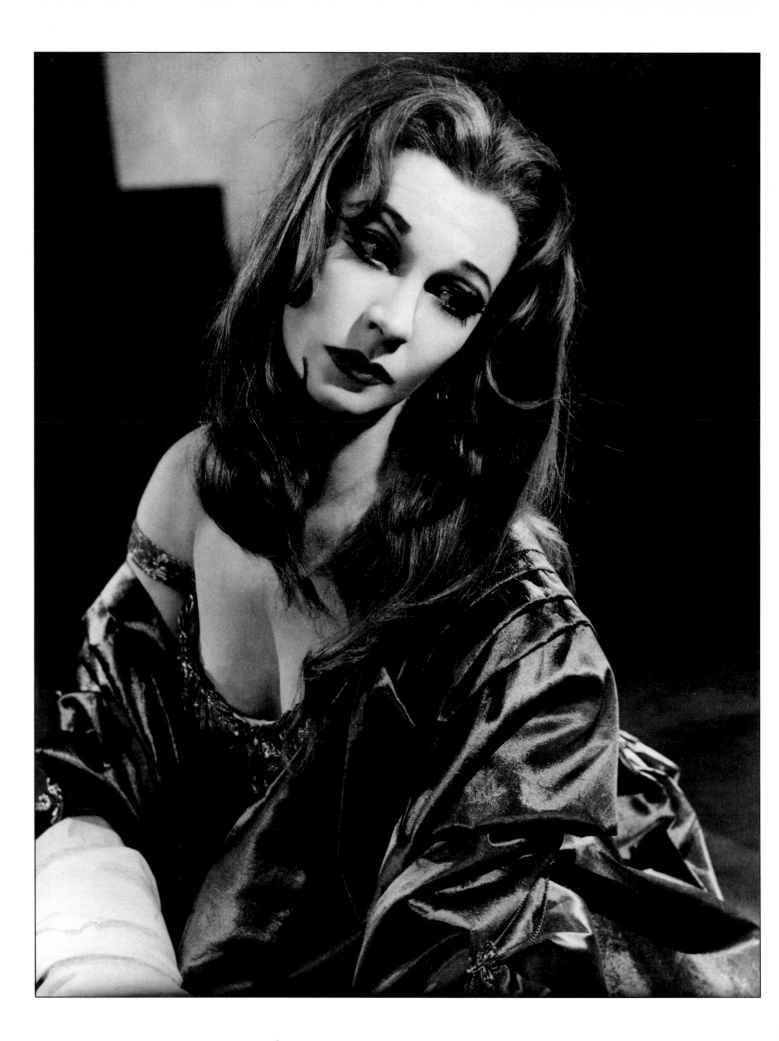

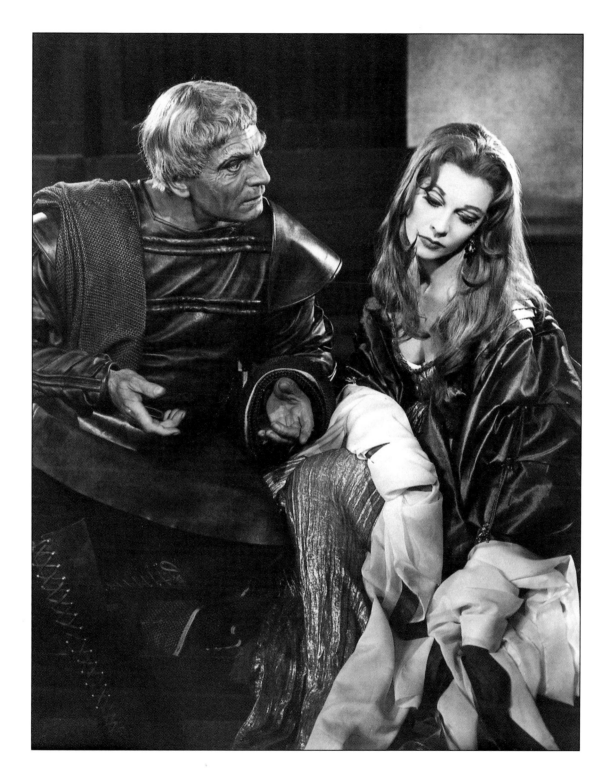

Lavinia, having been raped and mutilated.
(*above*) In a scene with her father Titus,
played by Laurence Olivier.

(*overleaf*) Two studio pictures taken during
the 1955–6 Stratford season. The one on the
right was Vivien's favourite.

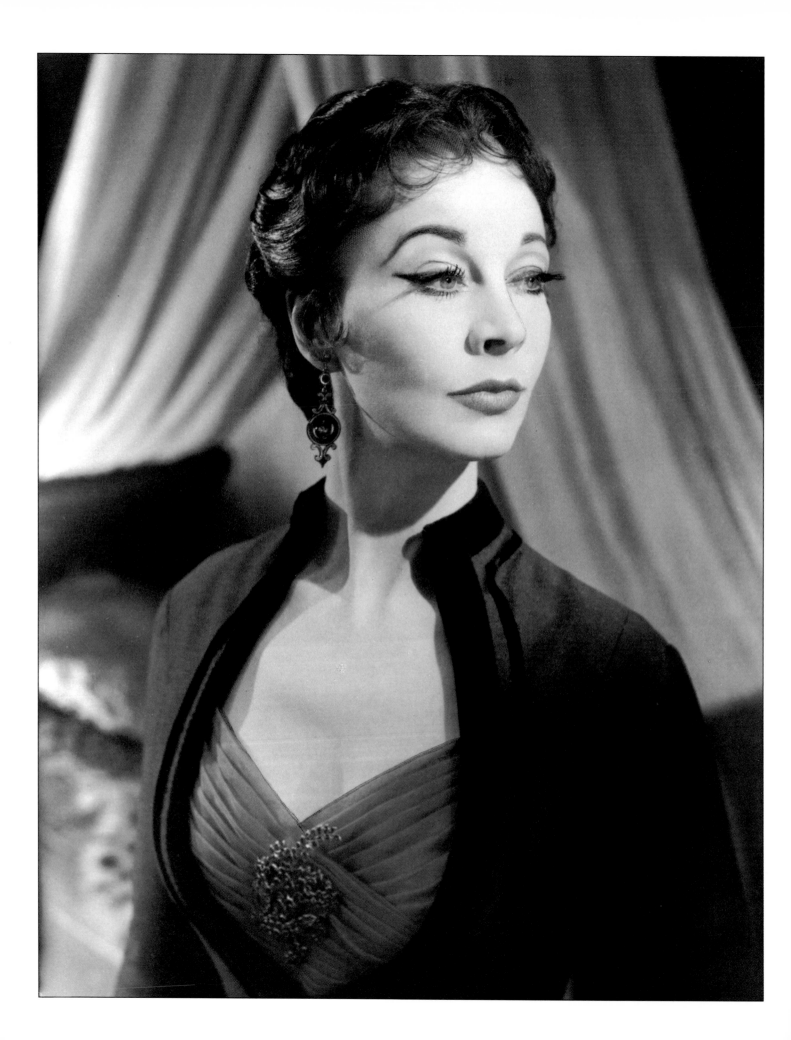

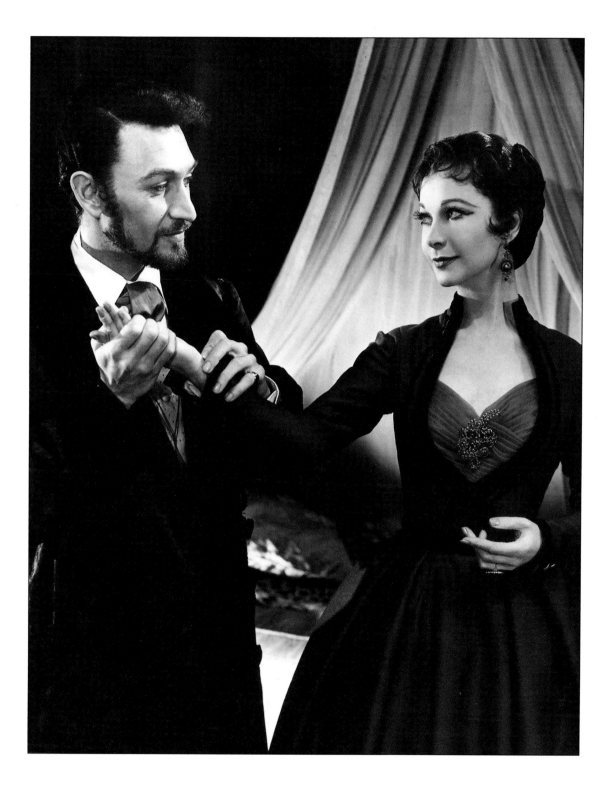

Vivien as Paola in Giraudoux's *Duel of Angels*
at the Apollo Theatre, London in 1958.
(*above*) With Peter Wingarde as Marcellus.

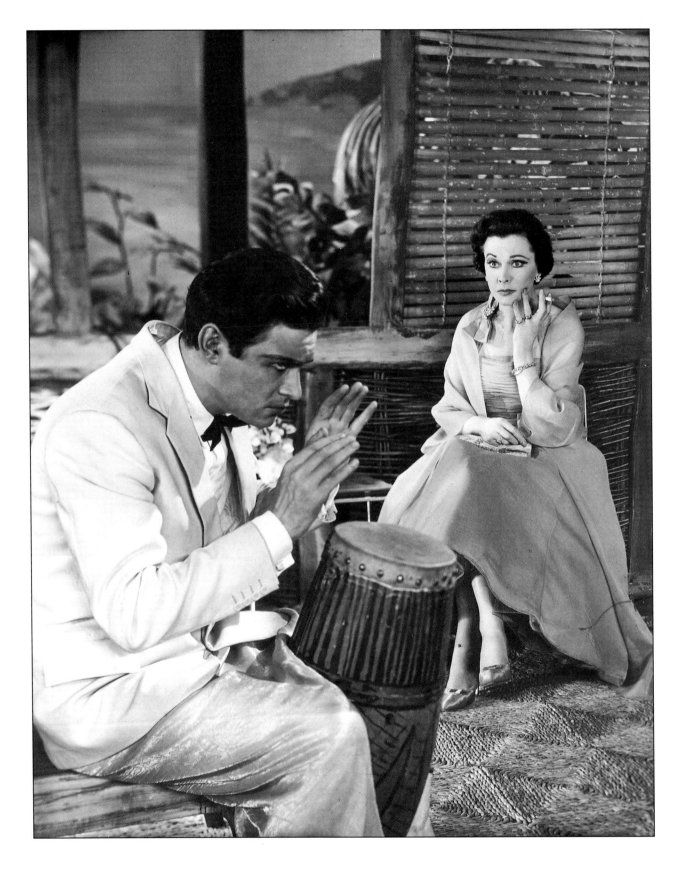

As Lady Alexandra Shotter in Noël
Coward's *South Sea Bubble*, which opened at
the Lyric Theatre in April 1956. Ronald
Lewis (*above*) played Hali Alani.

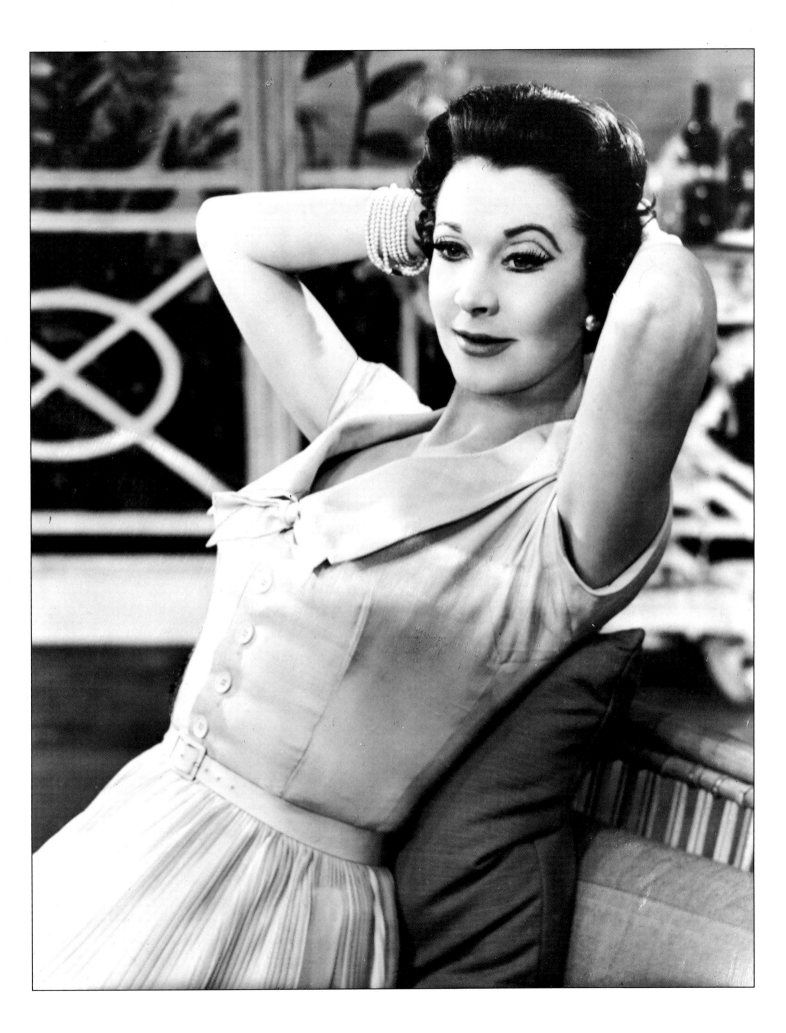

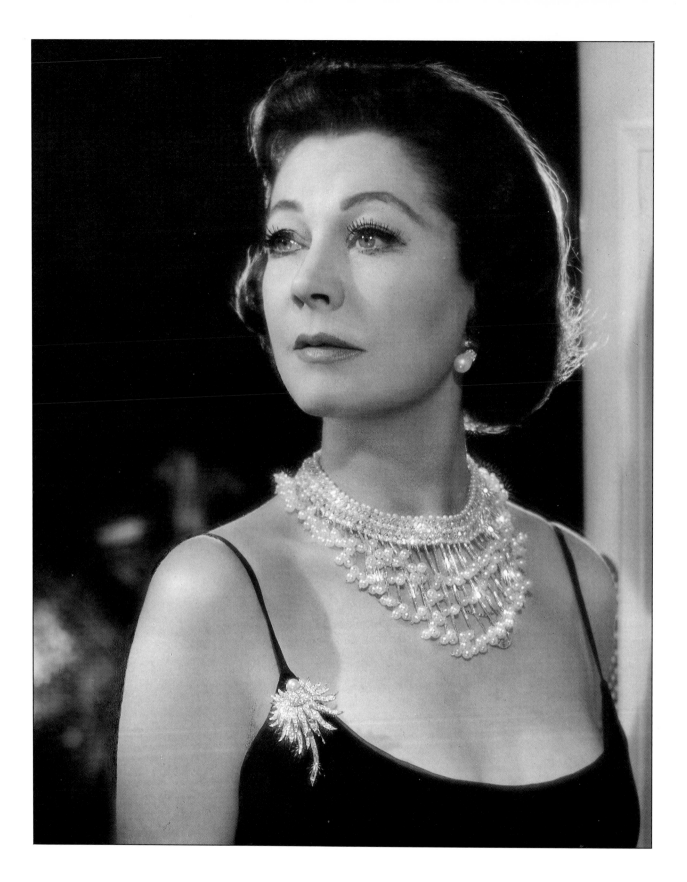

Two studio portraits of Vivien, taken in
1962. She was concerned about the fact that
she had put on weight, and said, 'don't make
me look too fat, Angus – my doctor said I
must put on a bit of weight and put me on
Guinness – which put on weight all right,
but in all the wrong places'.

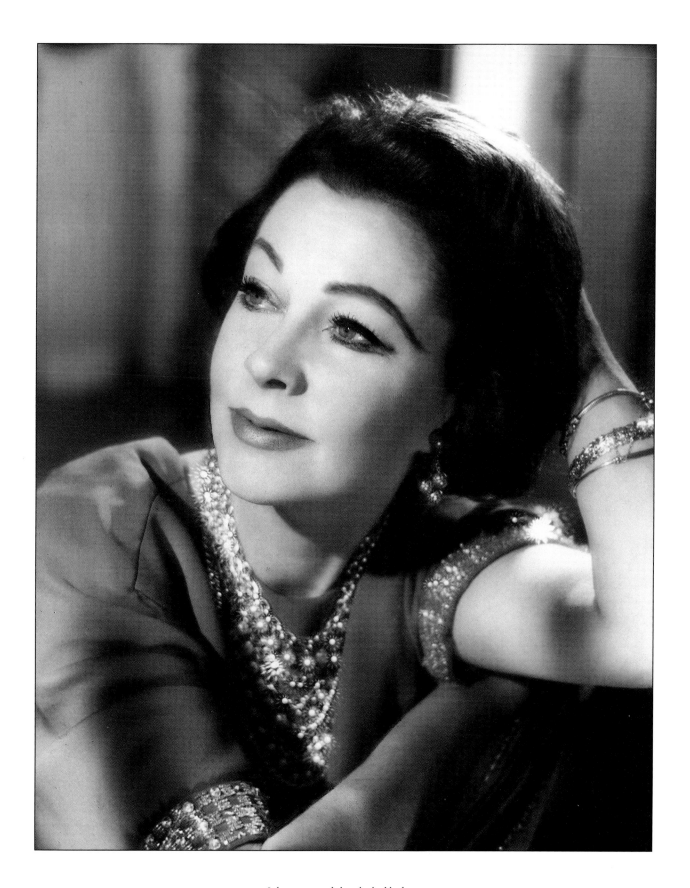

It later emerged that she had had an
alarming flare-up of the tuberculosis which
had long troubled her, and as she was
allergic to penicillin she had been put on
steroids. These pictures were taken as Press
shots before the filming of
The Roman Spring of Mrs Stone.

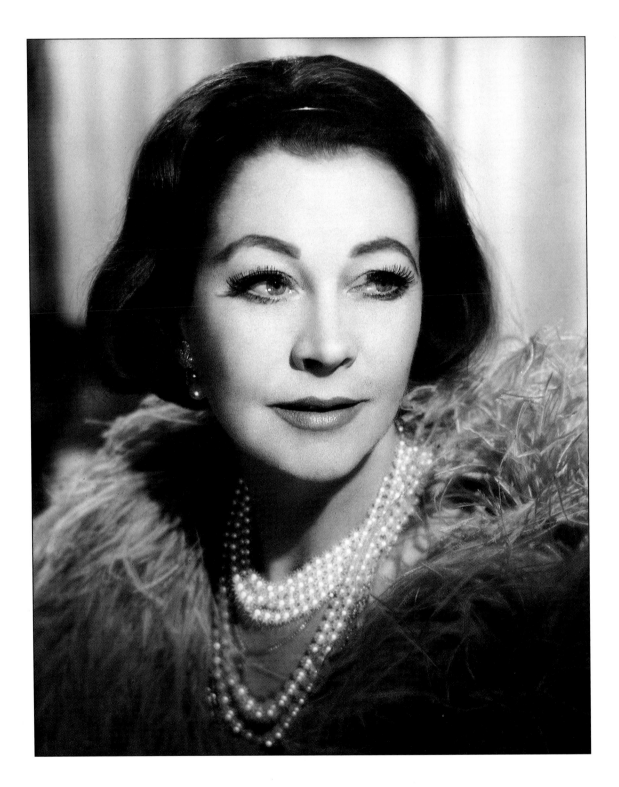

Two Press shots taken in the studio before
the filming of *Ship of Fools* in 1964. In the
picture above, she is wearing the feather boa
she wore in the dancing scene.

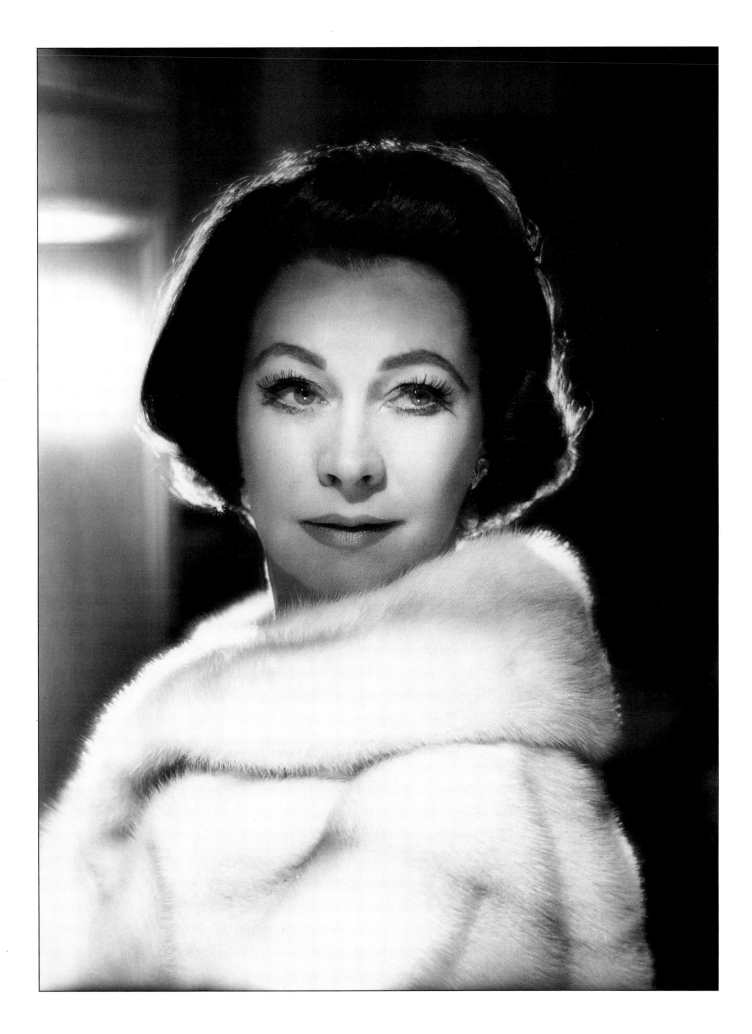

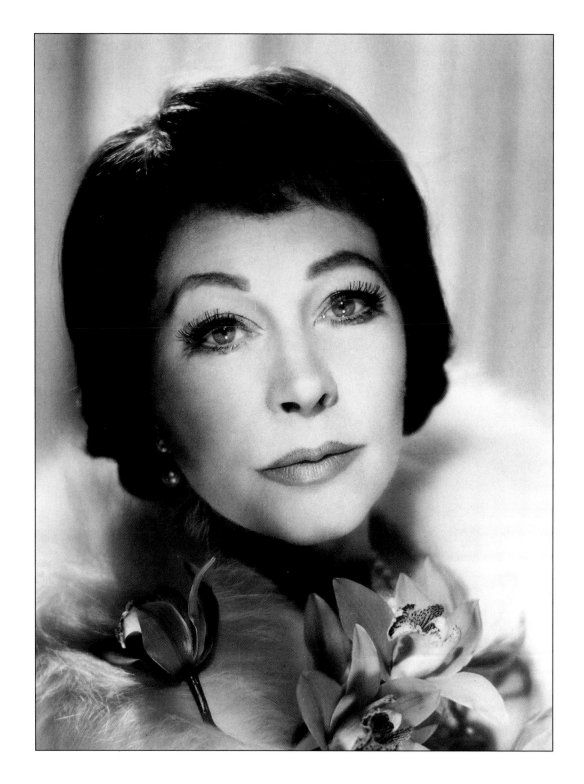

Vivien came to my studio in 1967 and
allowed me to take two 'glamour' shots of
her wearing a wig and false eyelashes. Then
she told me that, as she was now fifty-four
years old, she thought the 'glamour-puss'
pictures were out. She removed the wig and
eyelashes and put on ordinary street make-
up for a set of 'ordinary shots'.

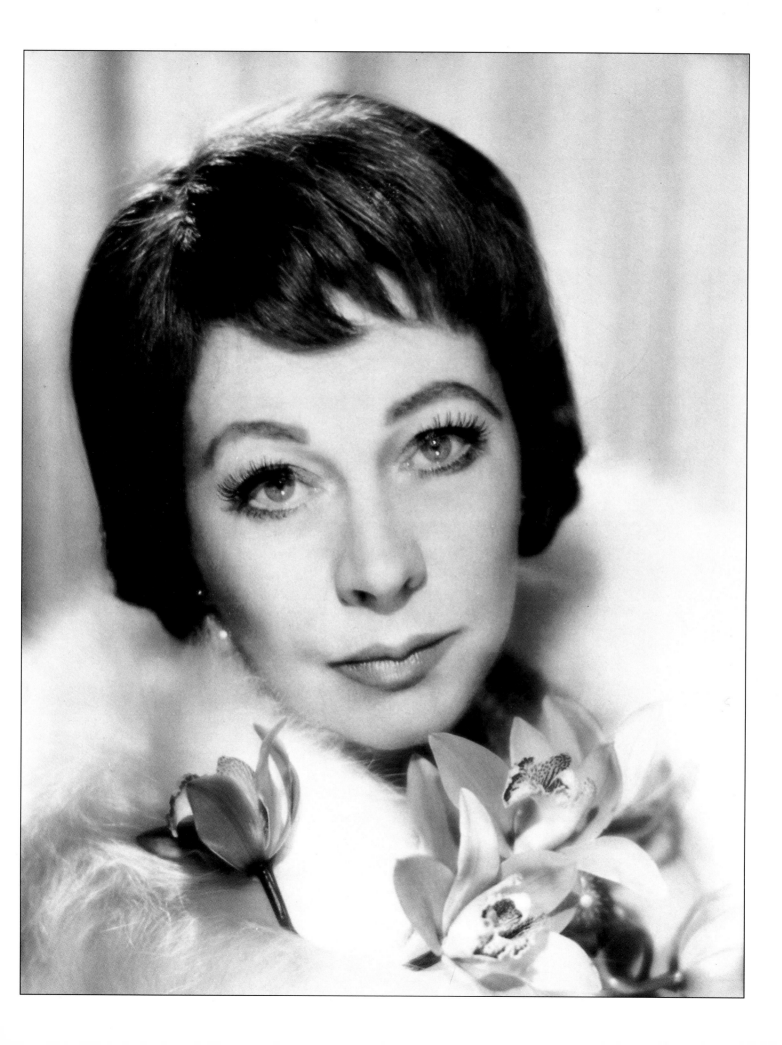

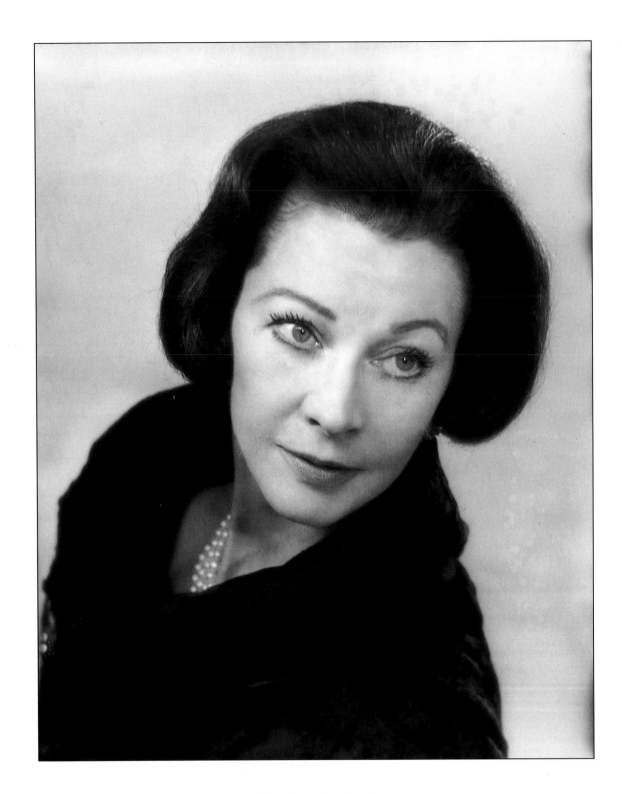

Two of the 'ordinary' shots from the 1967
studio session. The picture on the right was
Vivien's favourite. She wanted to use these
as publicity shots for her next play, *A Delicate
Balance* by Edward Albee, in which she was
to play a very unglamorous role. The
photographs were never used for this
purpose, however. Three weeks after they
were taken she was dead.

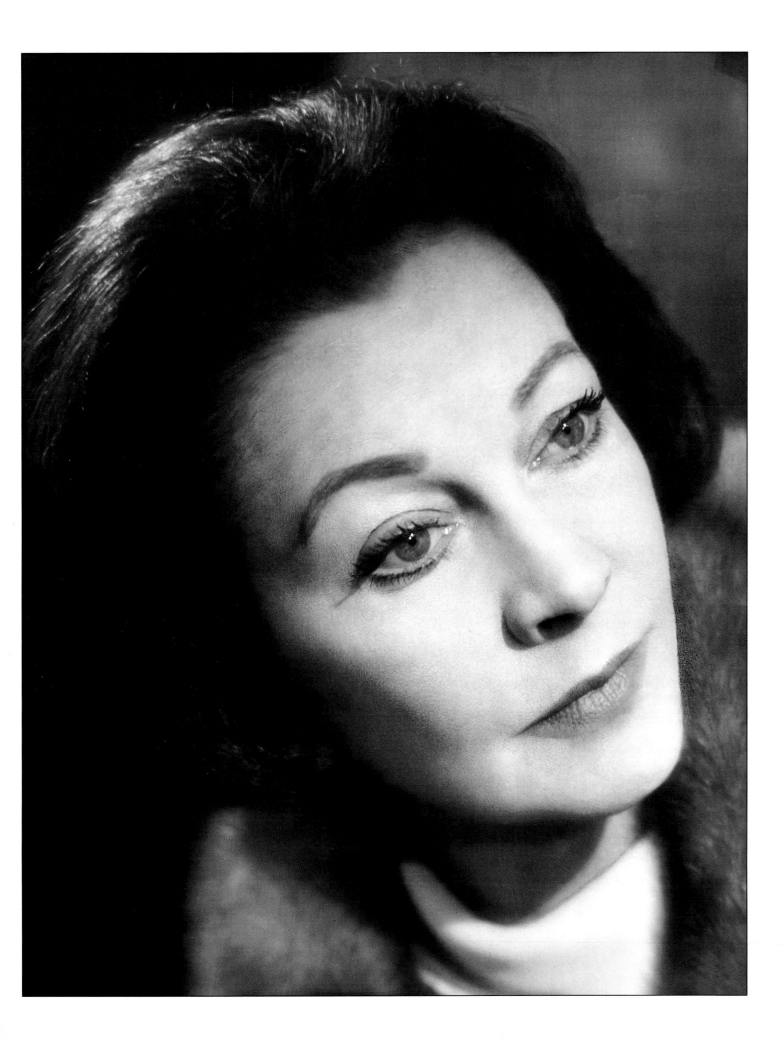

SELECT BIBLIOGRAPHY

COTTRELL, JOHN, *Laurence Olivier*, Weidenfeld & Nicolson, 1975

EDWARDS, ANNE, *Vivien Leigh*, W.H. Allen & Co. Ltd., 1977

HOLDEN, ANTONY, *Olivier*, Weidenfeld & Nicolson, 1988

LASKY JR, JESSE and SILVER, PAT, *Love Scene*, Angus & Robertson Ltd, 1978

O'CONNOR, GARY, *Darlings of the Gods*, Hodder & Stoughton, 1984

VICKERS, HUGO, *Vivien Leigh*, Hamish Hamilton, 1988

WALKER, ALEXANDER, *Vivien*, Weidenfeld & Nicolson, 1987

WOODHOUSE, ADRIAN, *Angus McBean*, Quartet Books, 1982

INDEX